Adult Coloring Book

Stress Relieving Abstract, Celtic, Damask, Flourish, Flower, Mandala, Ornament, Patterns, Vintage Designs

Includes 51 Pages PDF for FREE

Copyright © 2016 by FiHow Publishing
www.FiHow.com
ISBN-13: 978-1539339076
ISBN-10: 1539339076

All right reserved. No part of this publication may be reproduced, distributed, or transmitted in any form or by any means, including photocopying, recording, or other electronic or mechanical methods, without the prior written permission of the publisher.

- ✓ 50 Delectable Coloring Pages
- ✓ Single-Sided Pages At 8.5"X11"
- ✓ Release Your Anger By Coloring
- ✓ Unique, Beautiful Patterns
- ✓ Includes Digital PDF Bonus Inside

How To Use This Book

1. Break Out Your Crayons Or Colored Pencils.

2. Turn Off Your Phone, Tablet, Computer, Whatever.

3. Find Your Favorite Page In The Book. That Is The Beginning.

4. Start Coloring.

5. If Your Notice At Any Point That You Are Forgetting Your Worries, Daydreaming Freely Or Feeling More Creative, Curious, Excitable, Delighted, Relaxed Or Any Combination Thereof, Take A Deep Breath And Enjoy It. Remind Yourself That Coloring, Like Dancing Or Falling In Love, Does Not Have A Point. It Is The Point.

6. When You Don't Feel Like It Anymore, Stop.

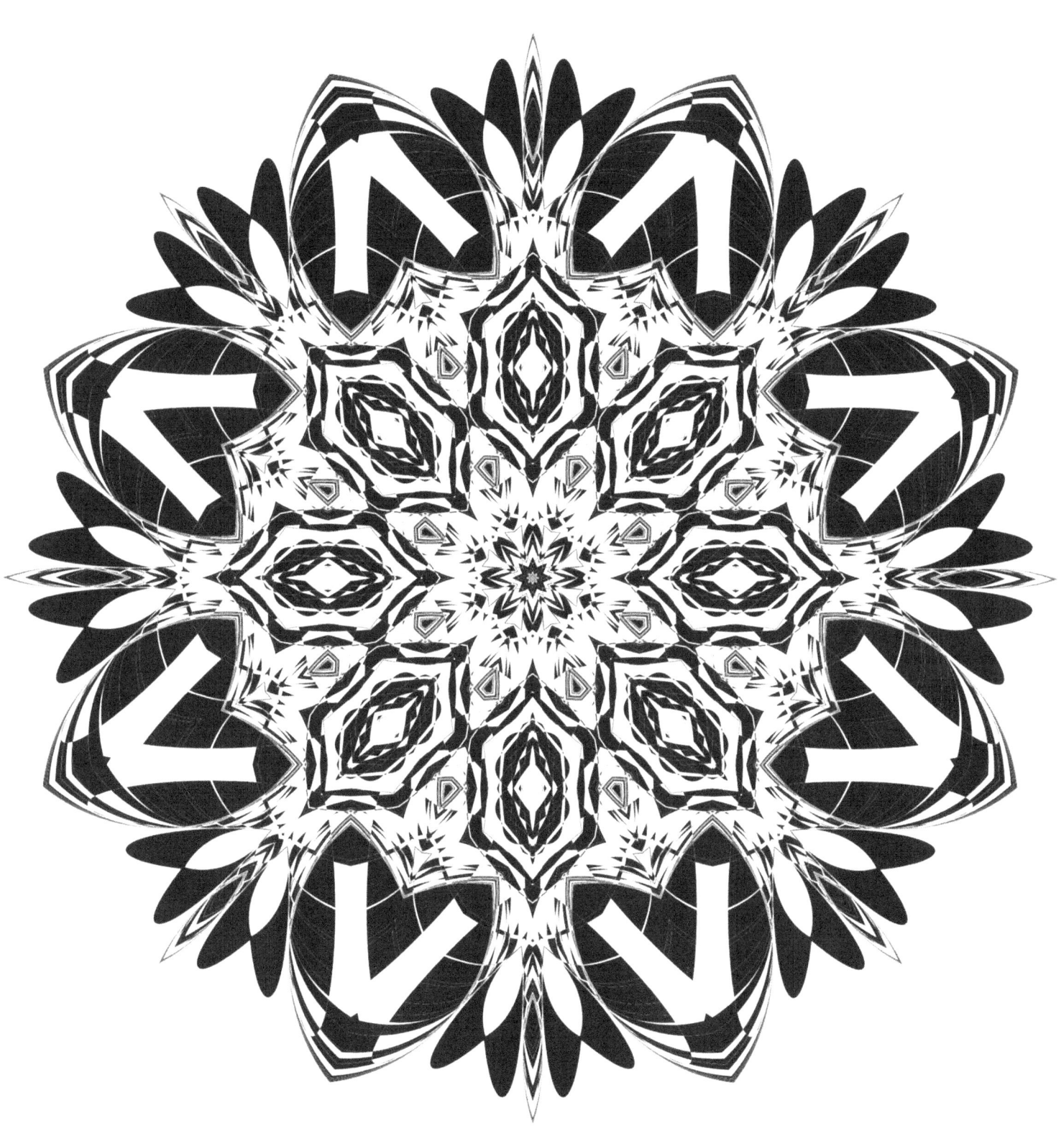

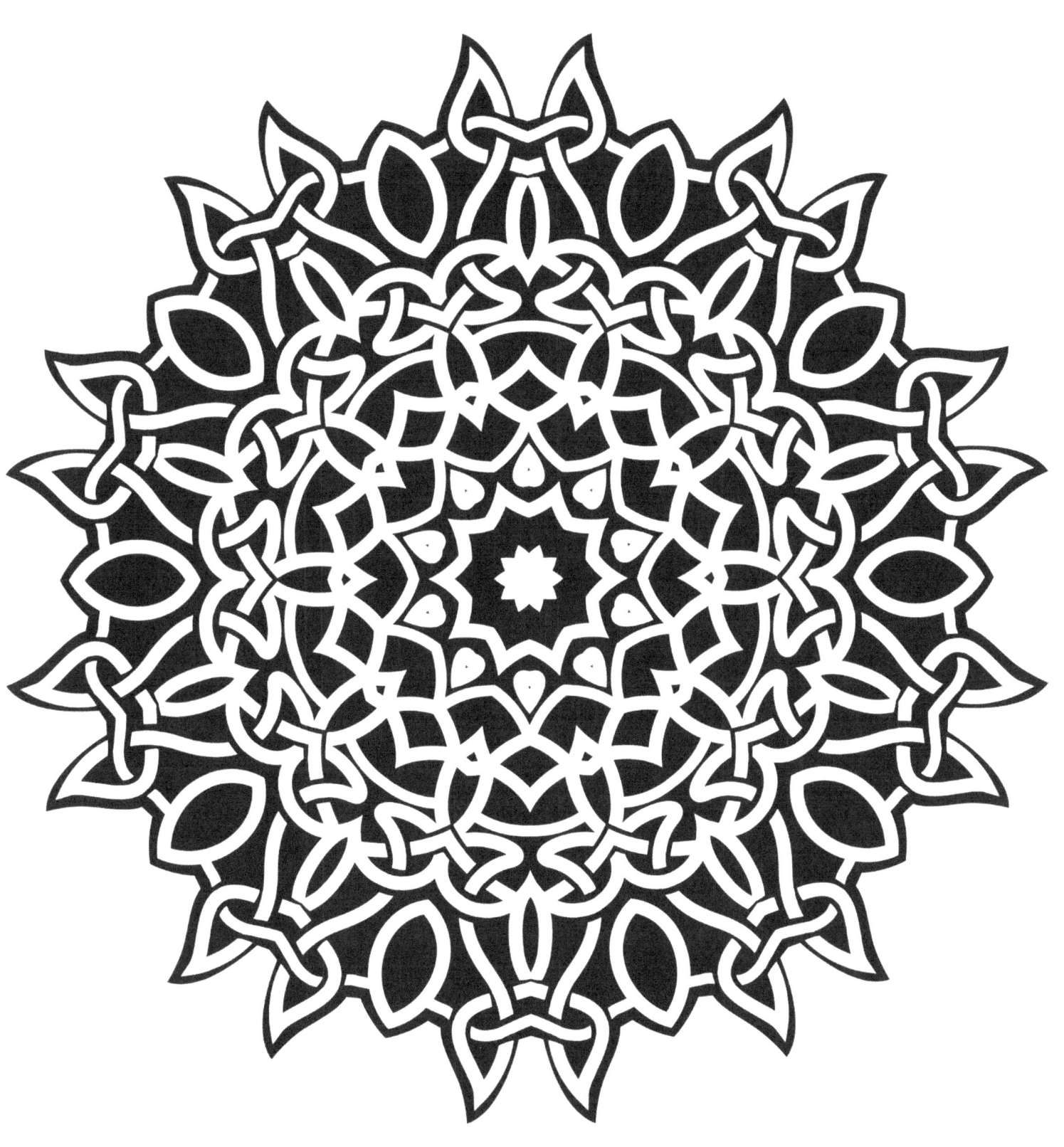

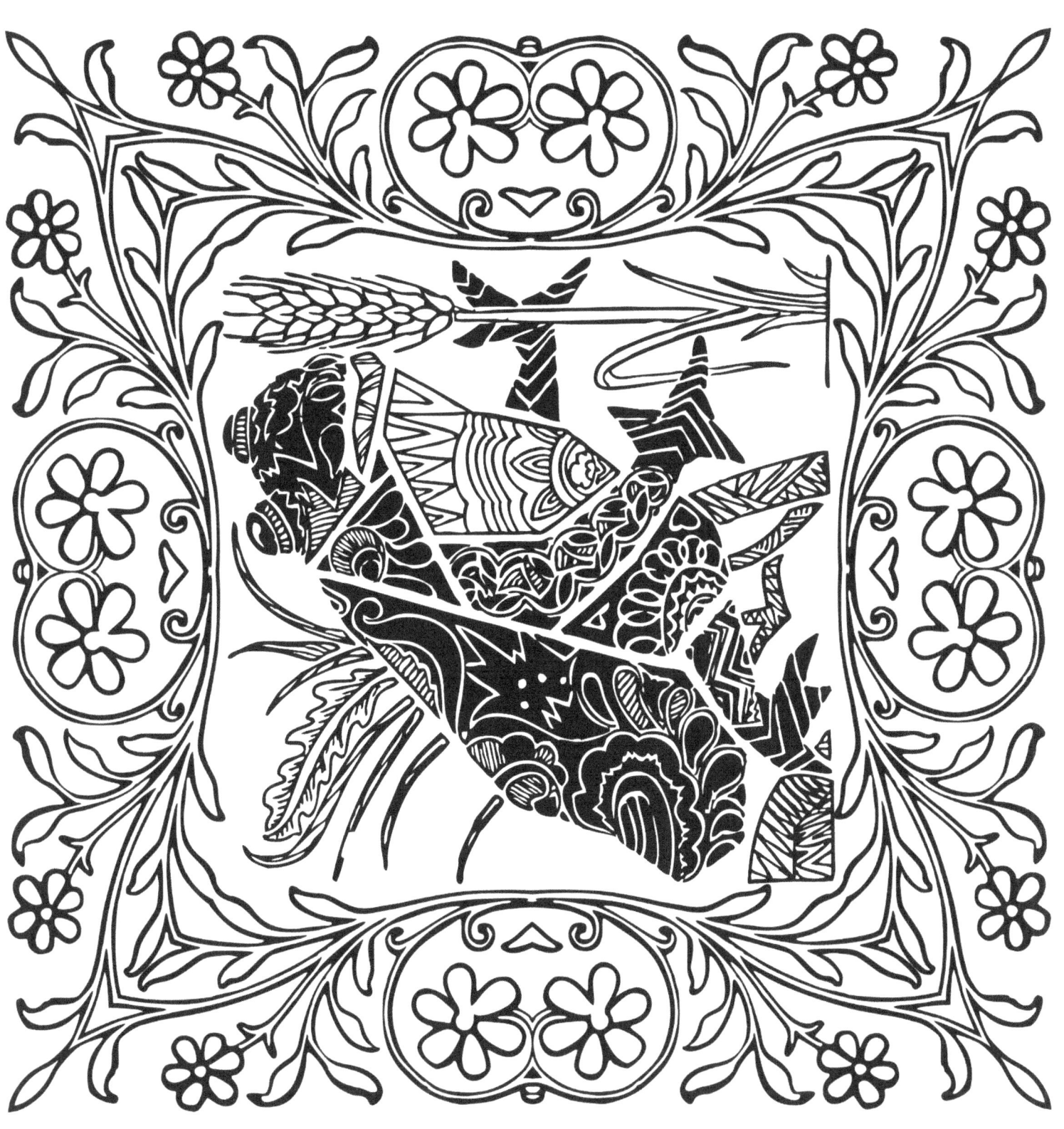

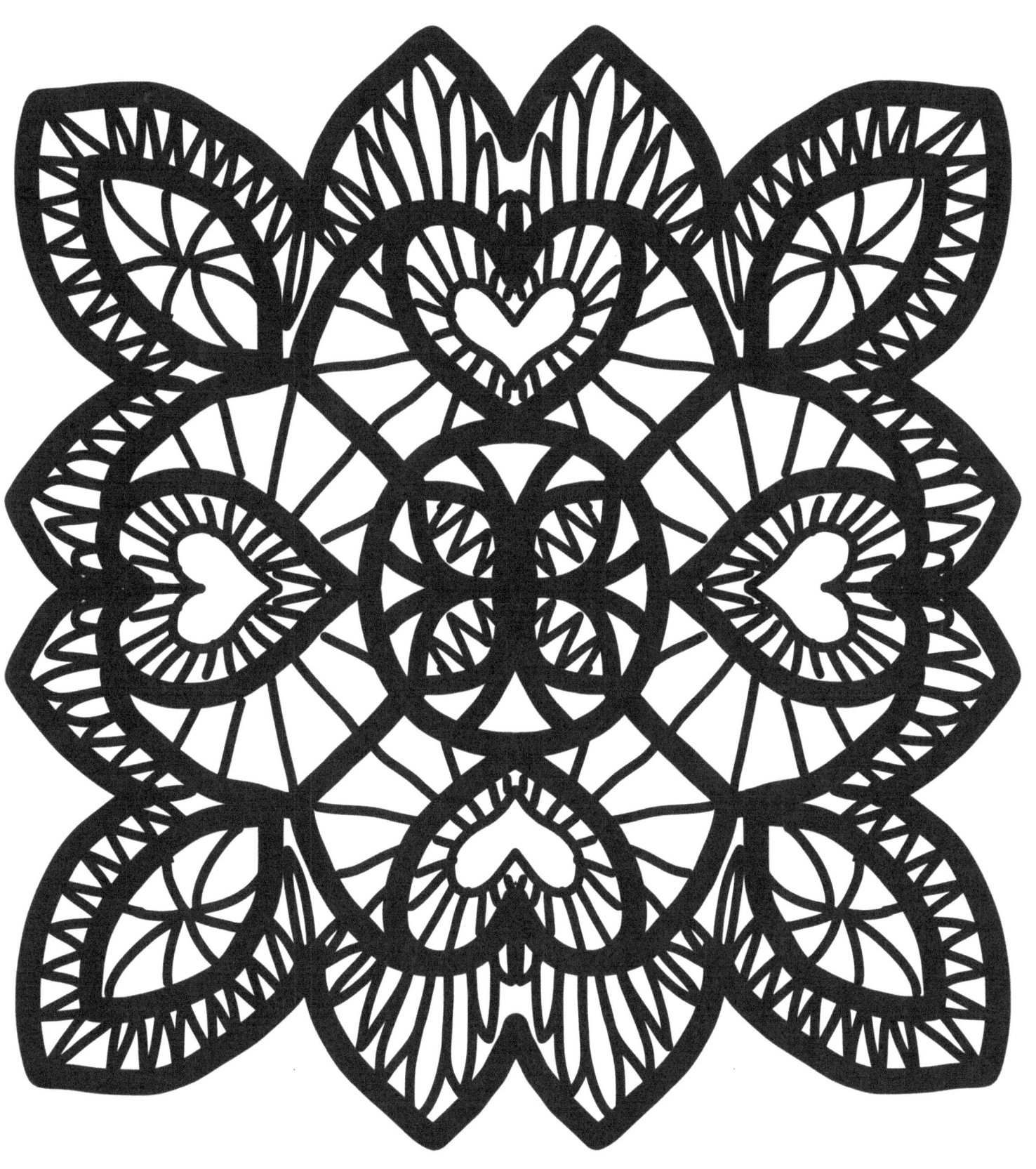

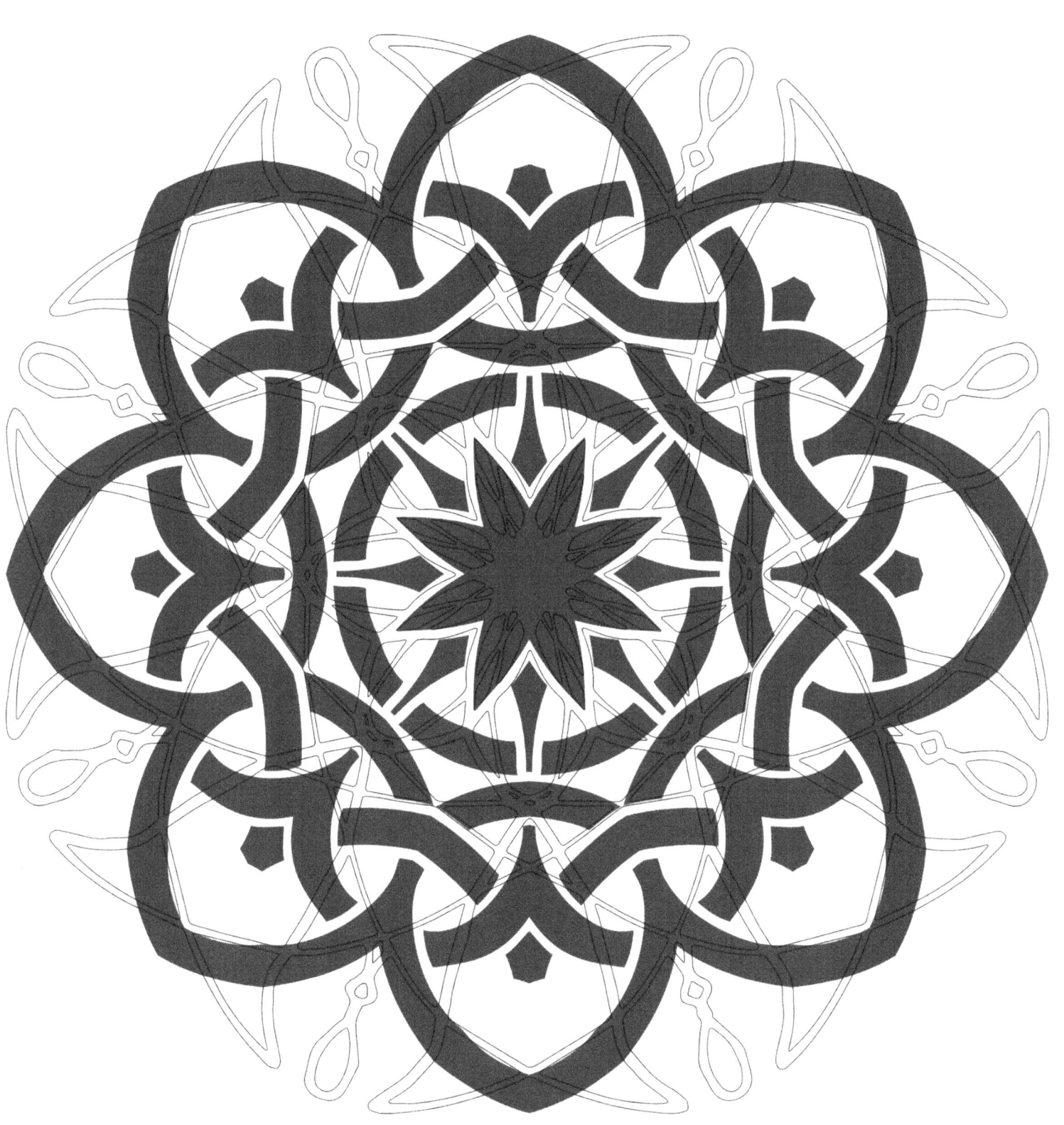

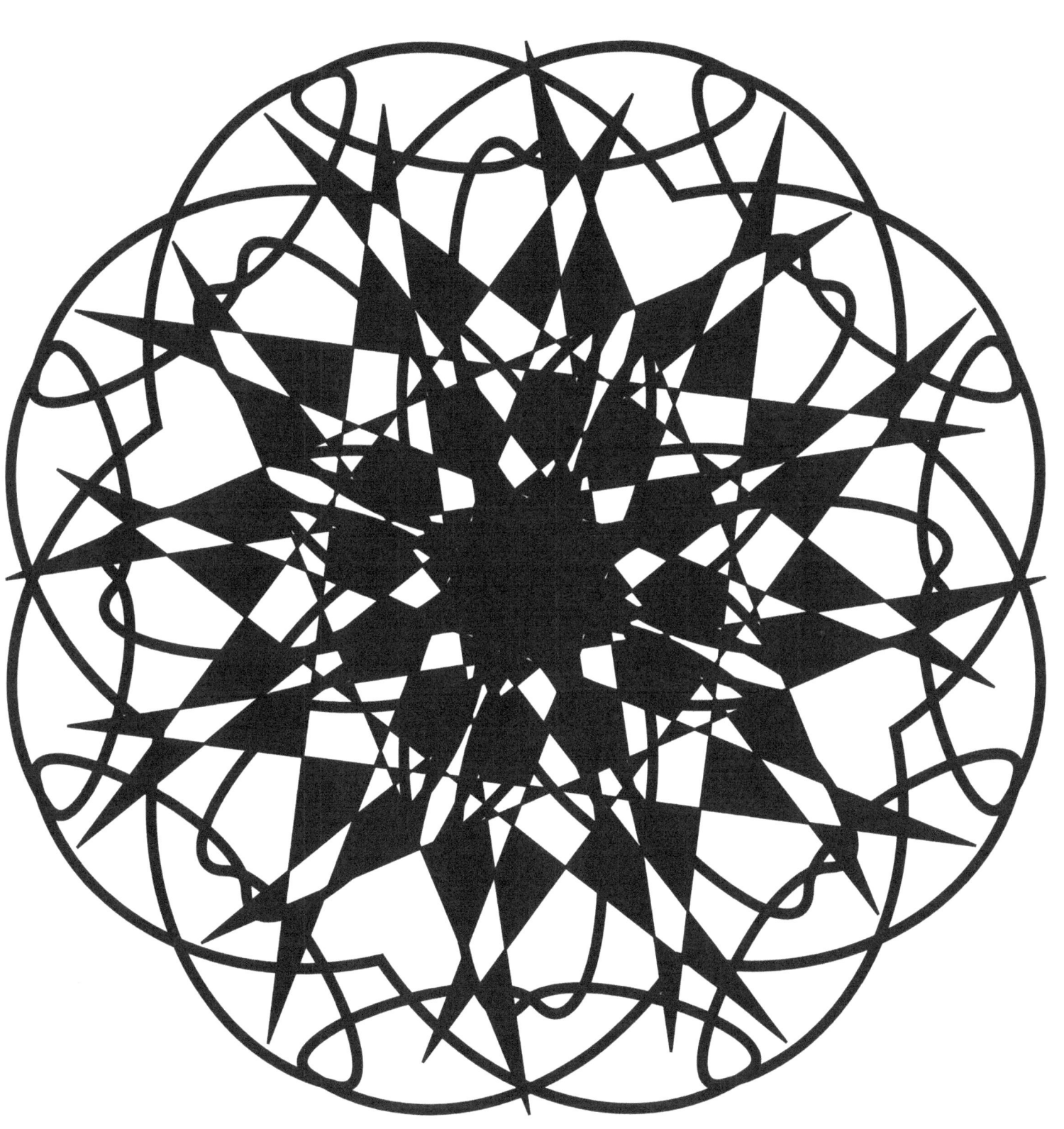

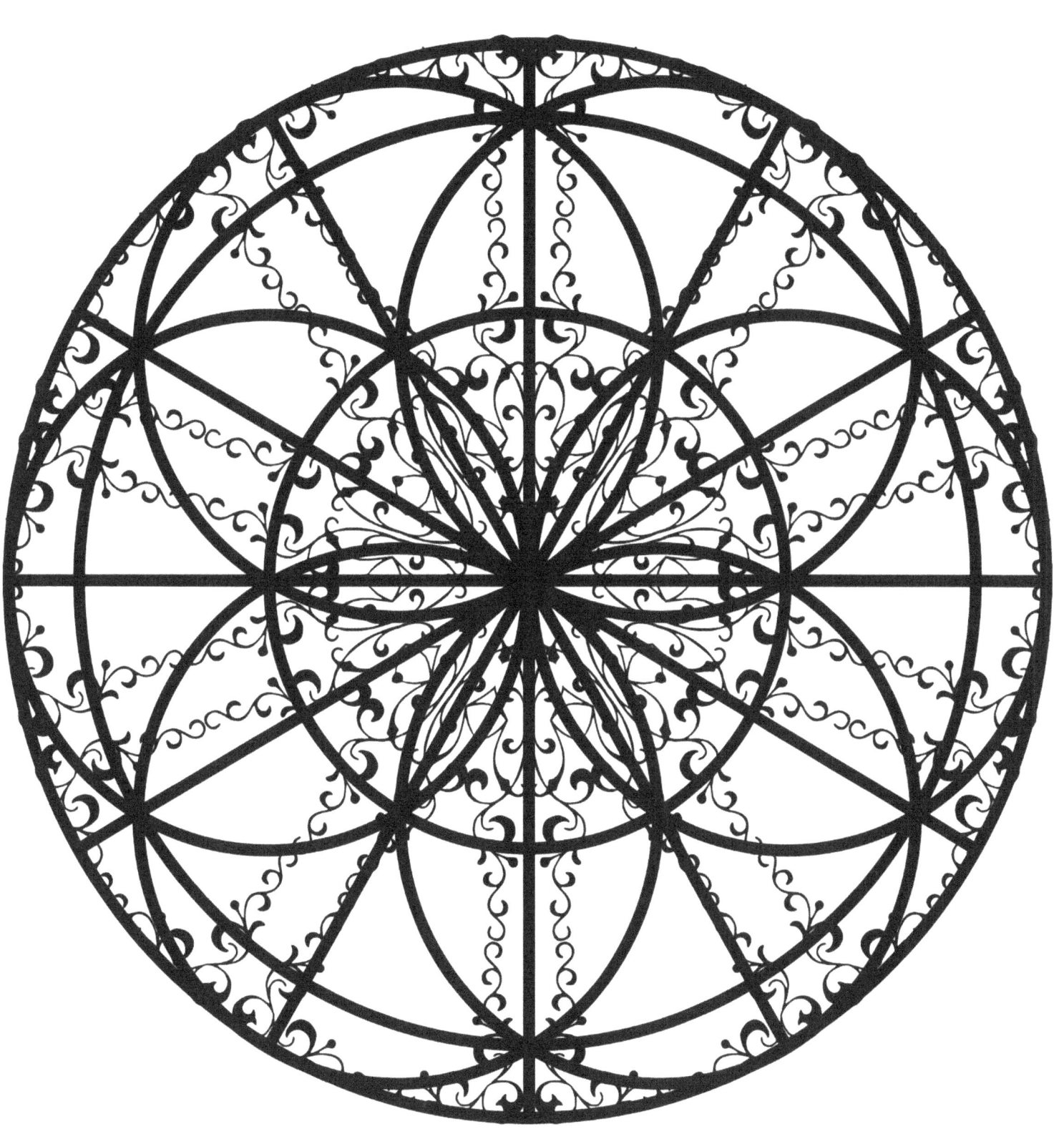

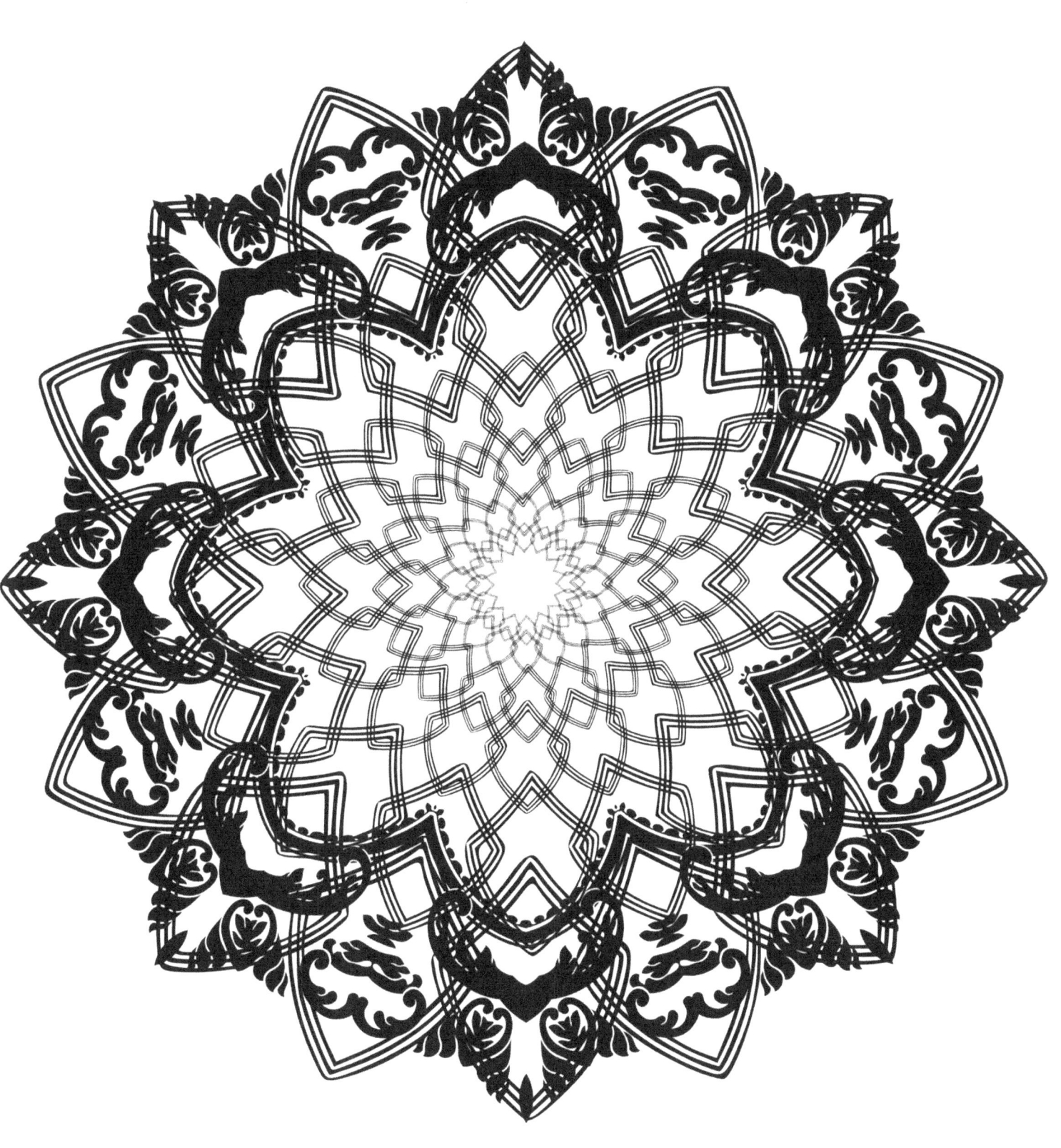

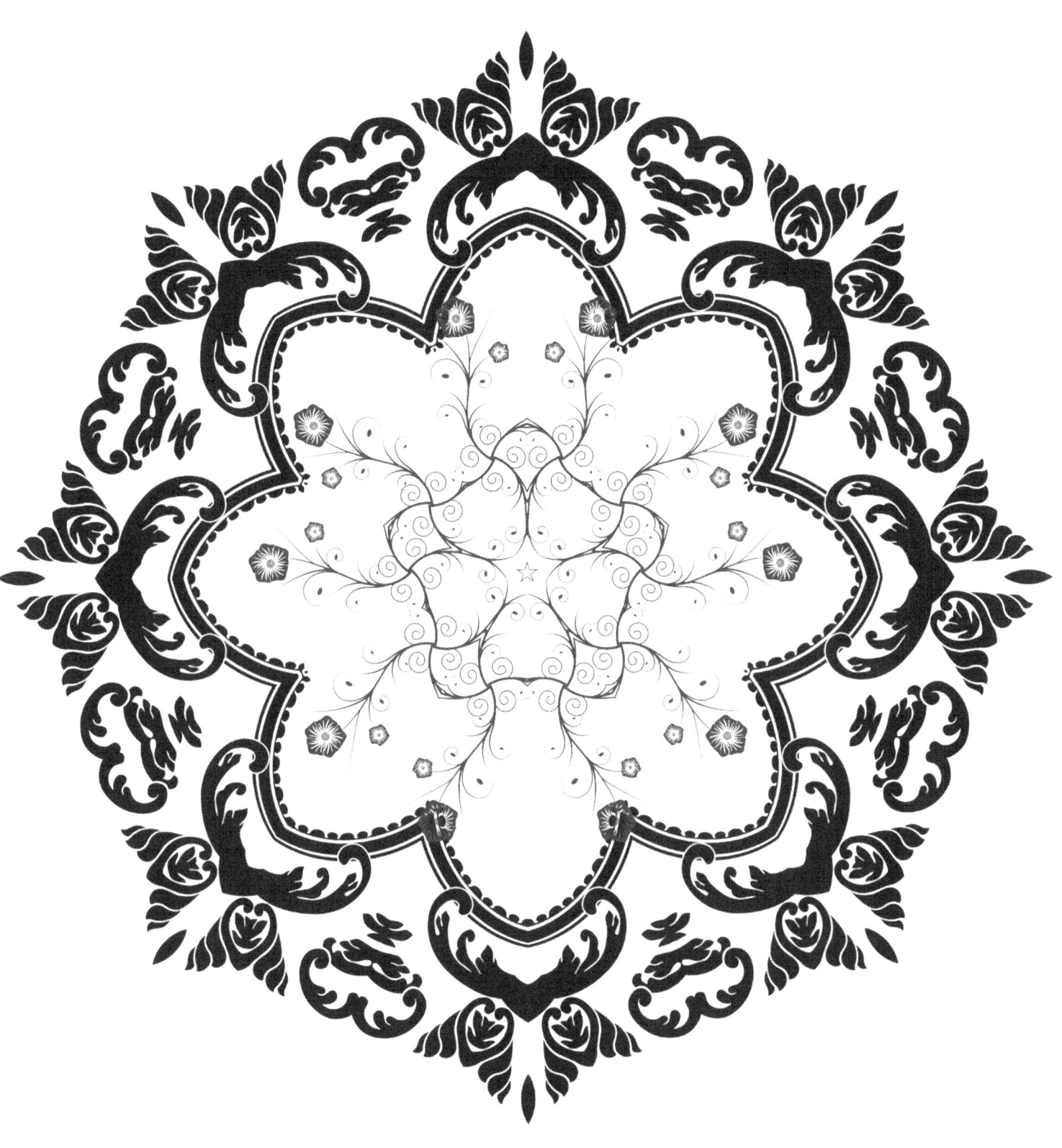

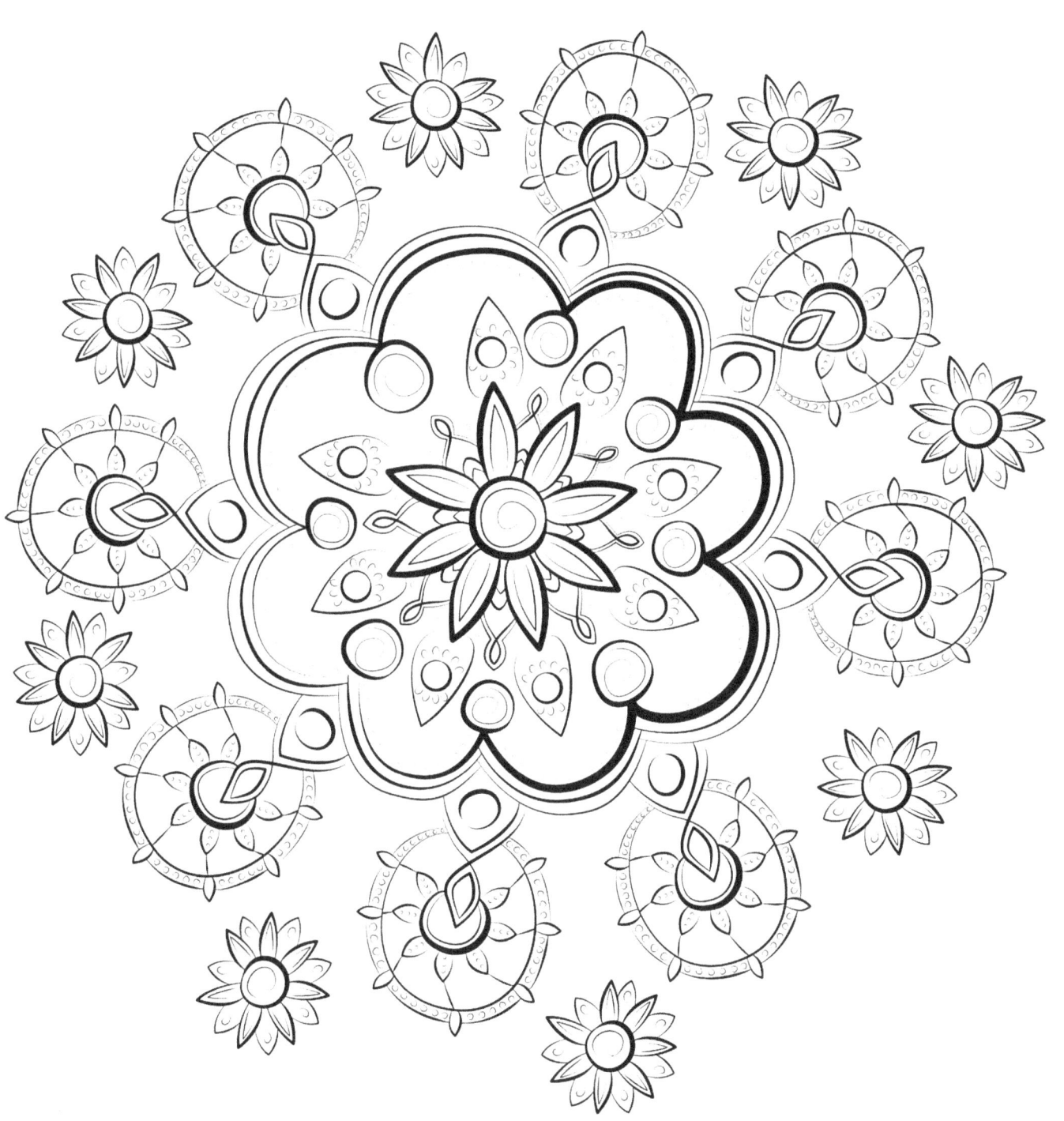

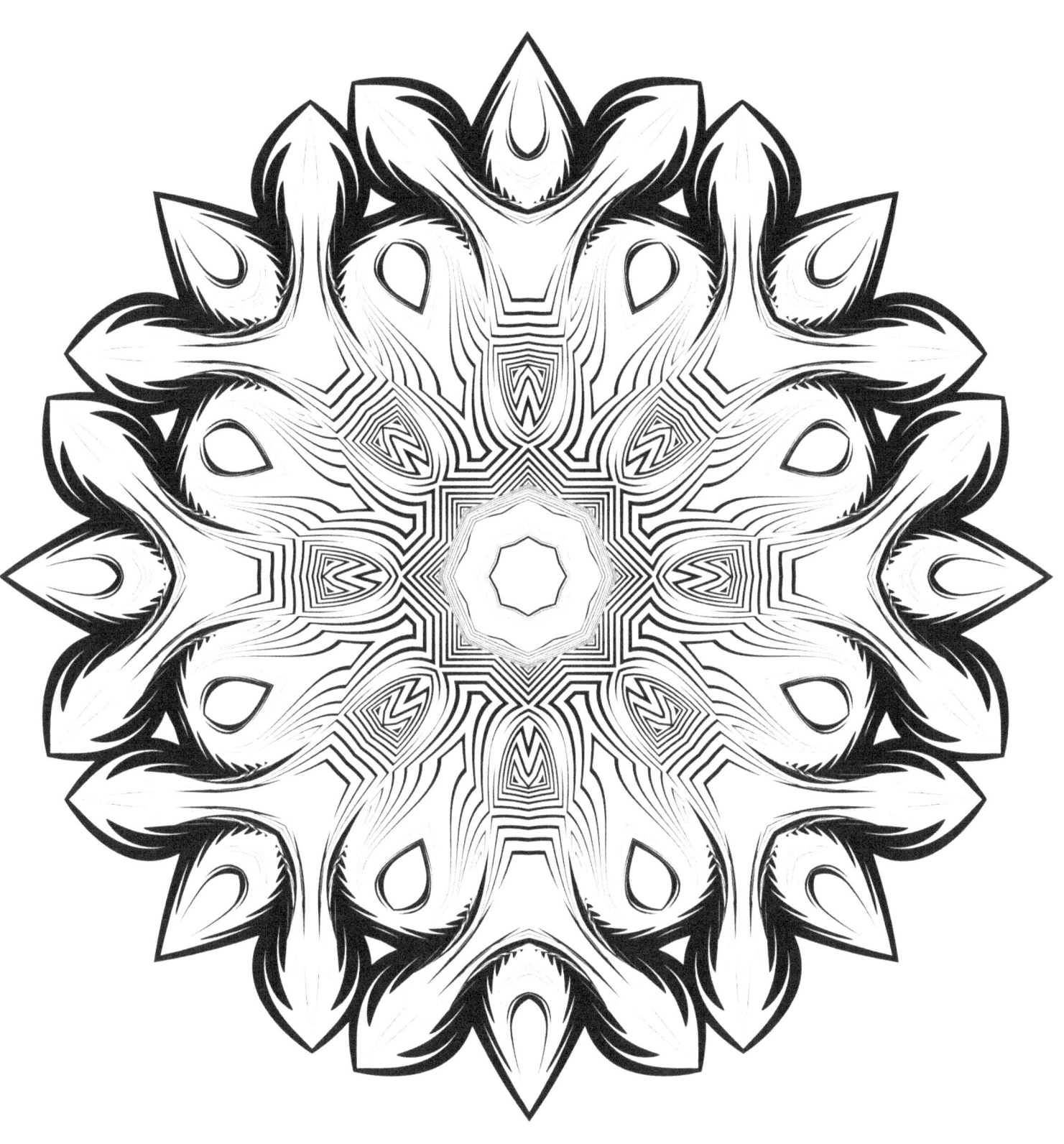

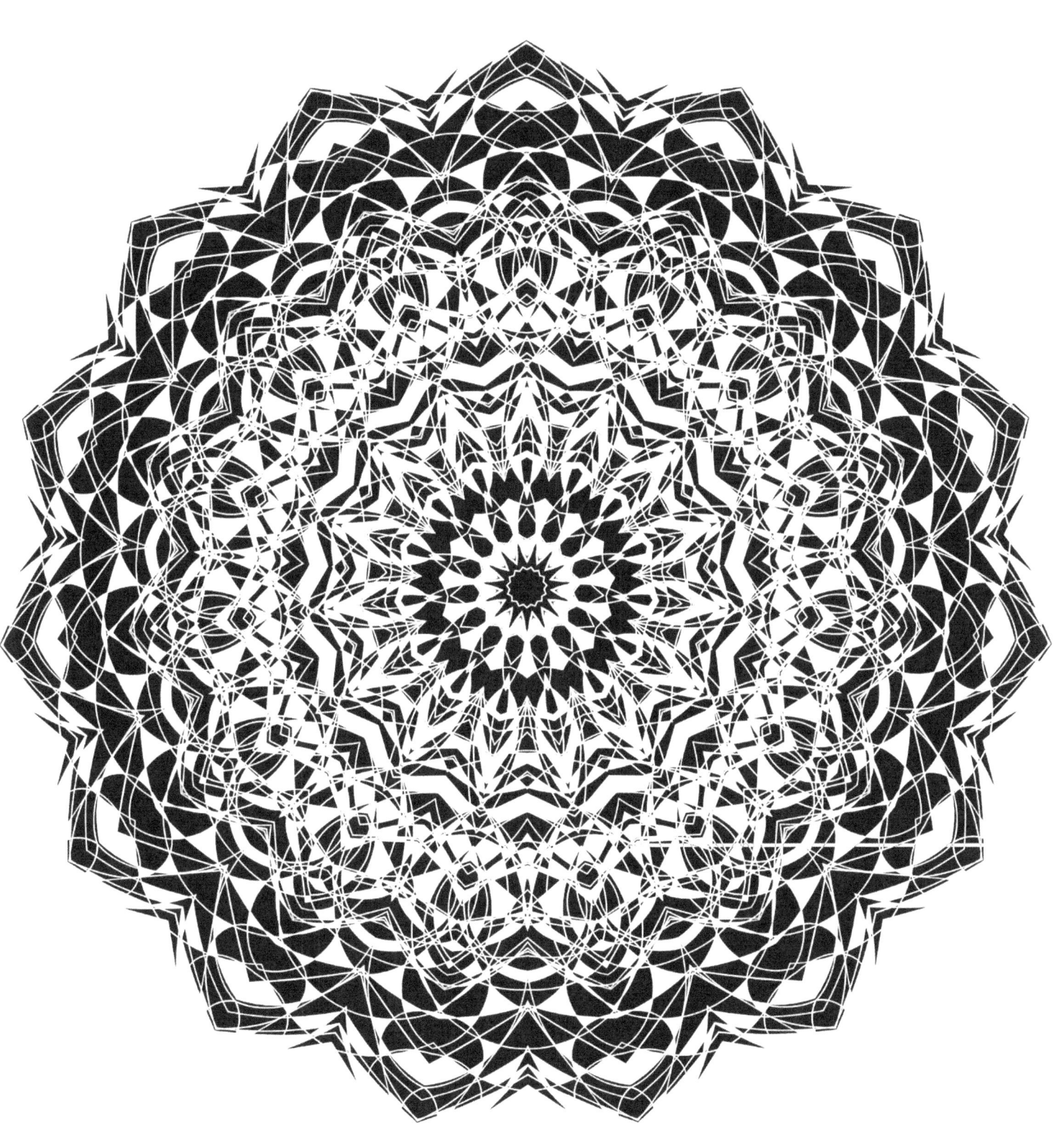

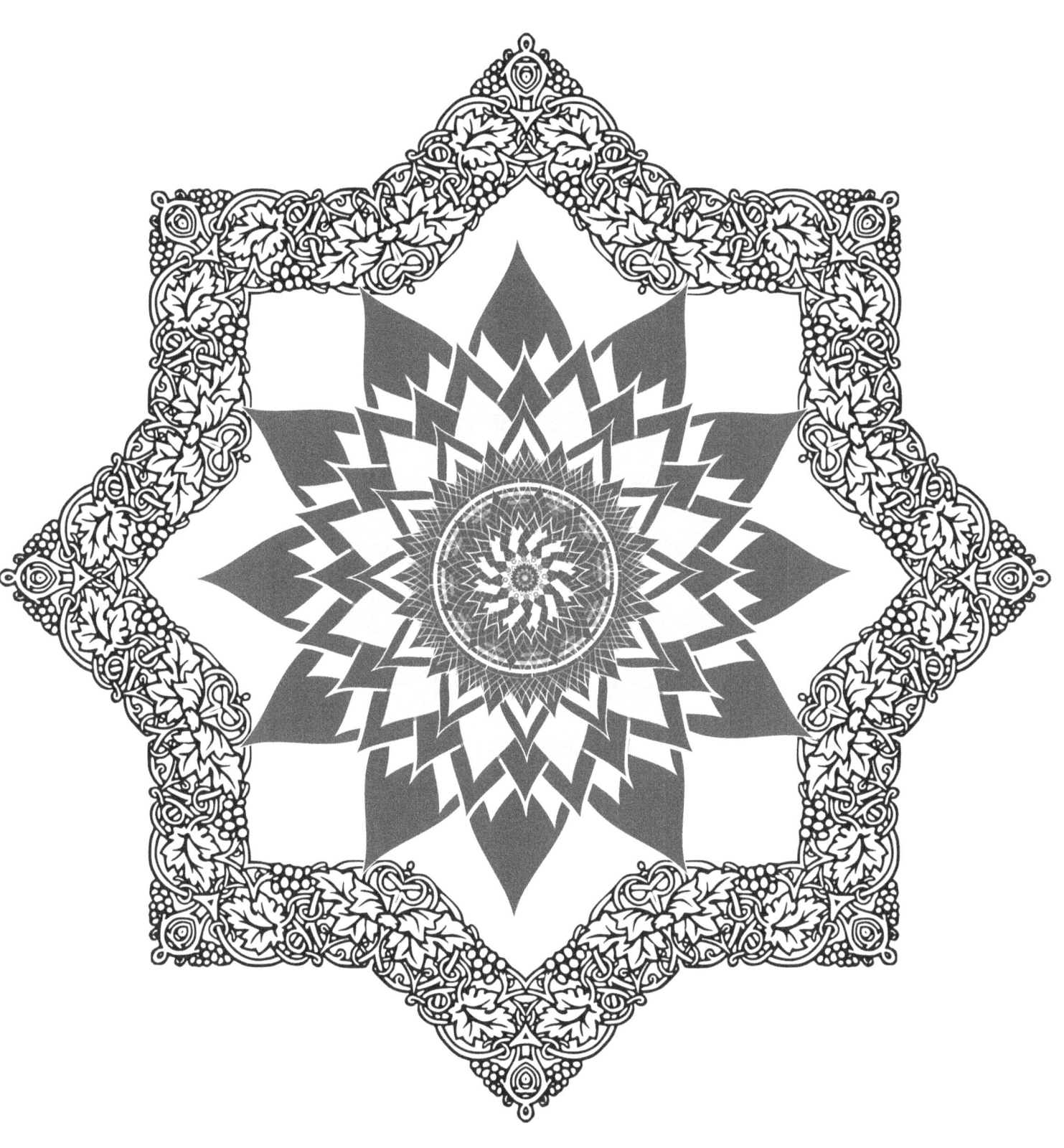

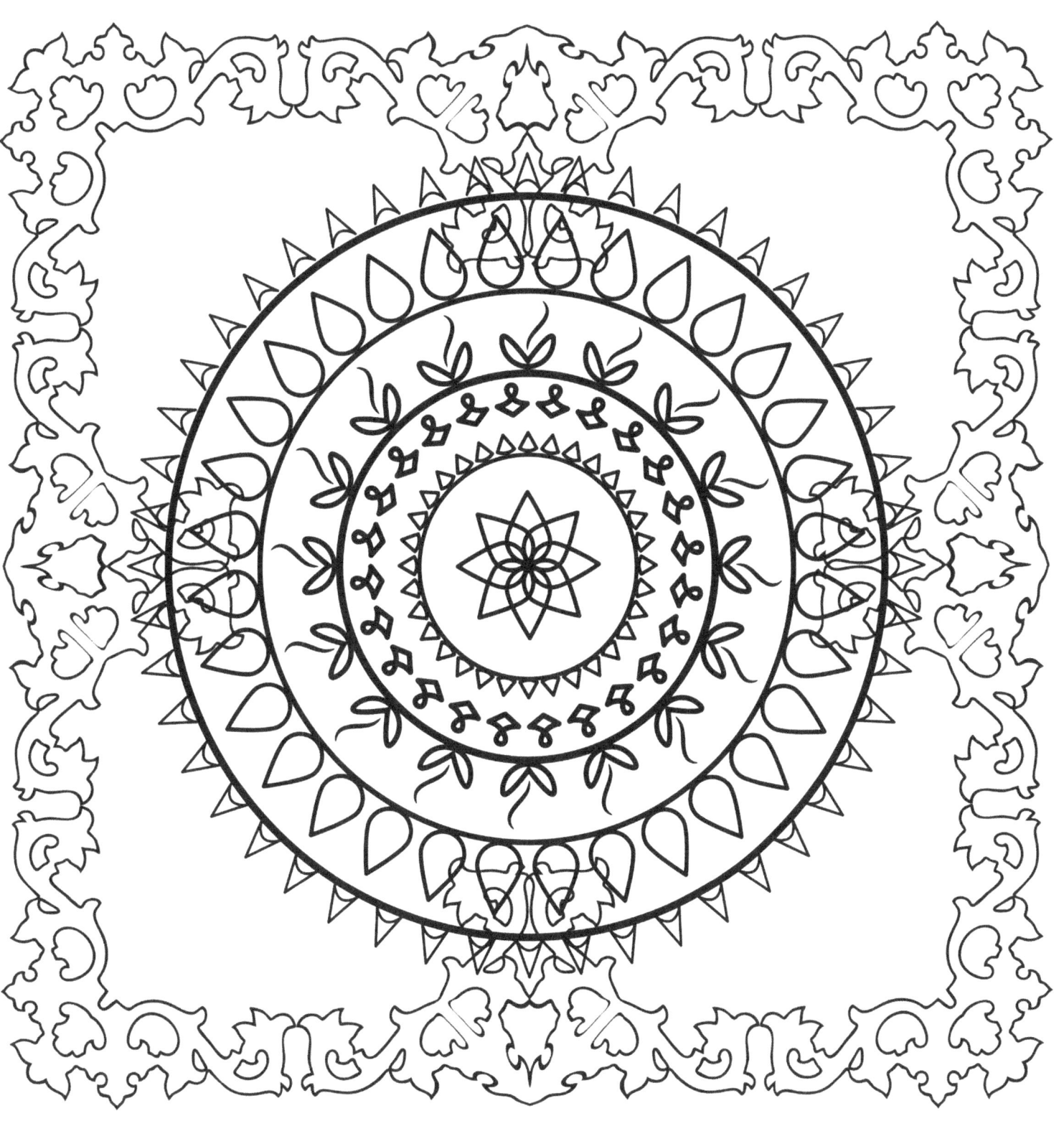

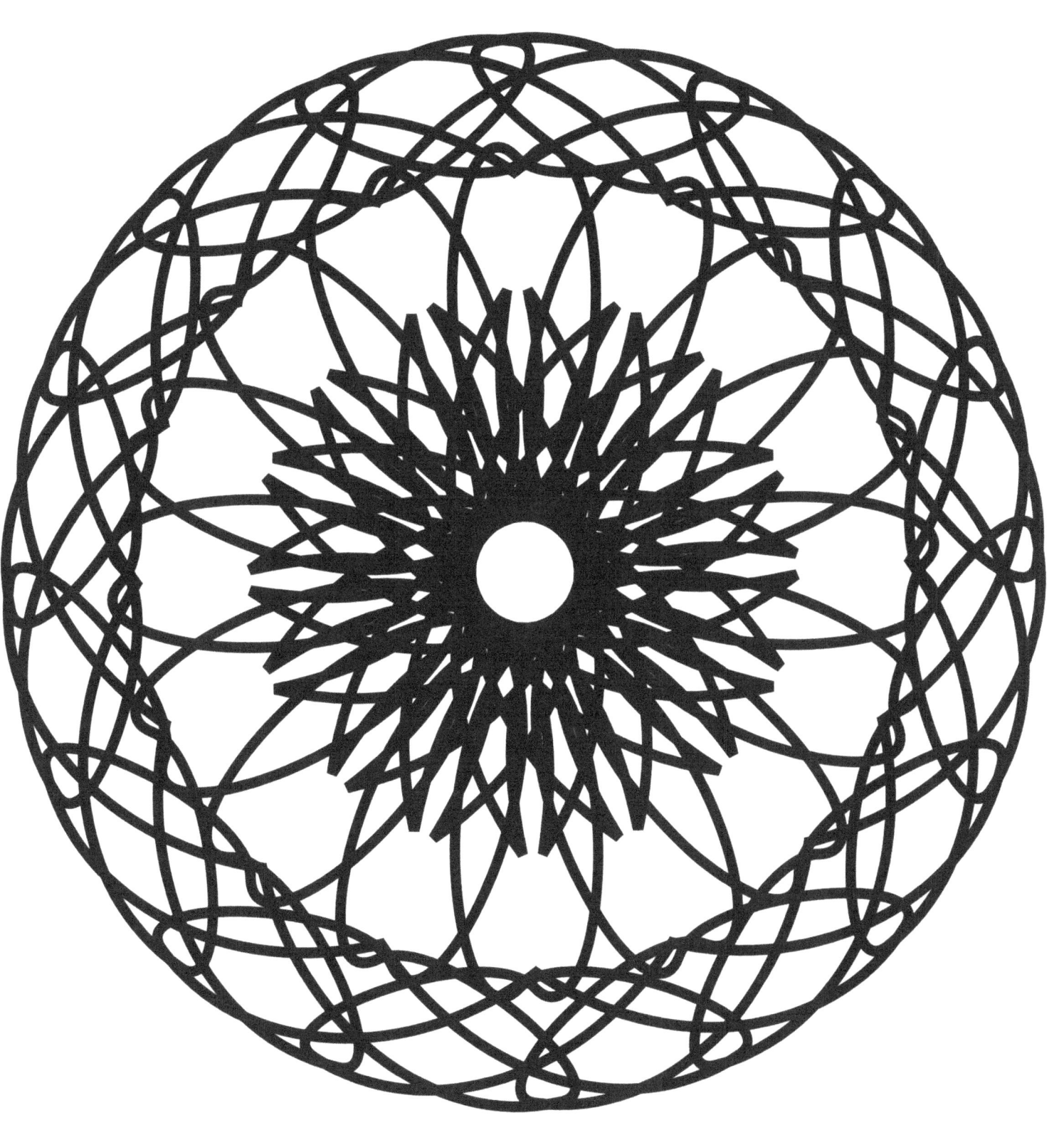

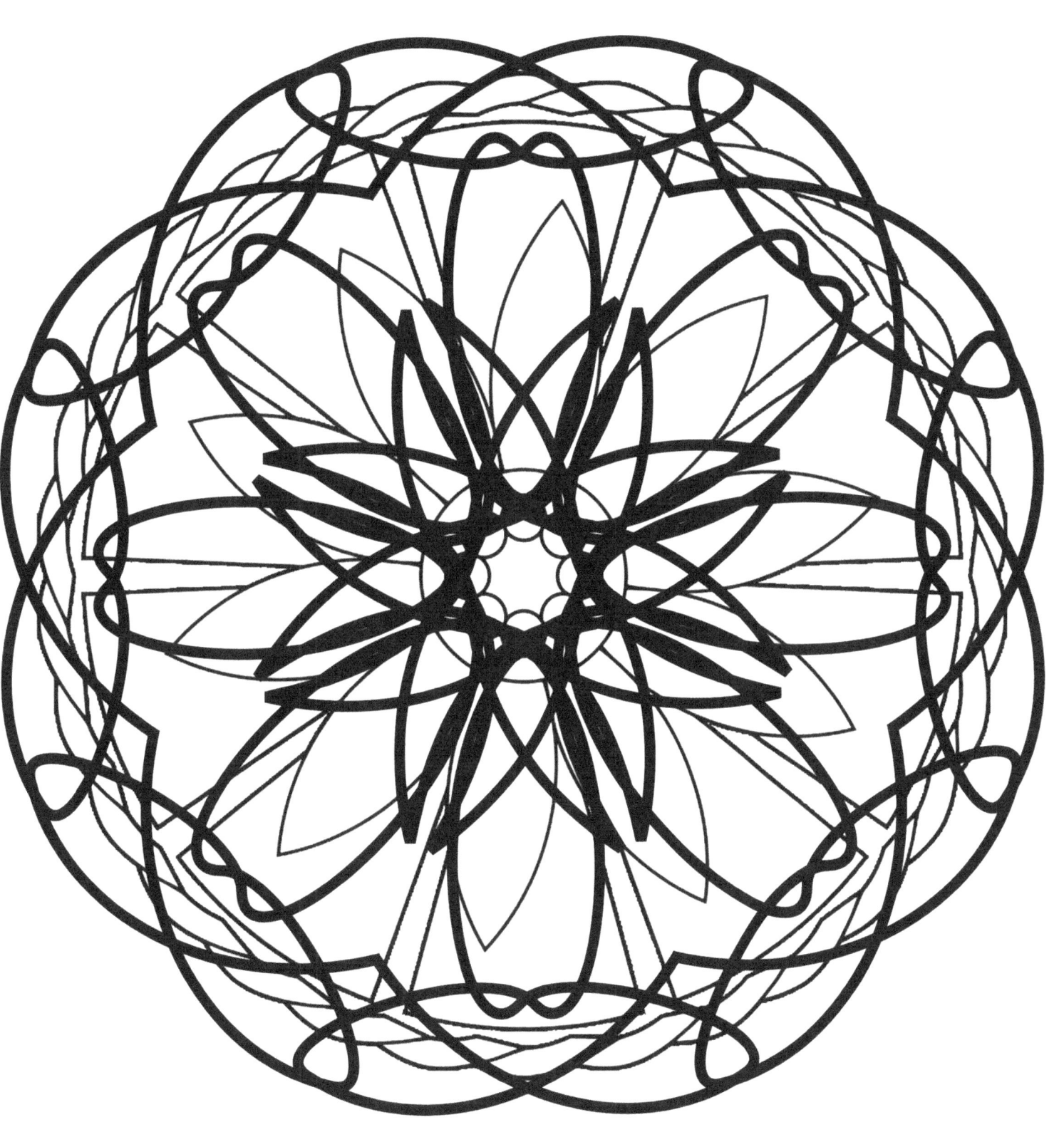

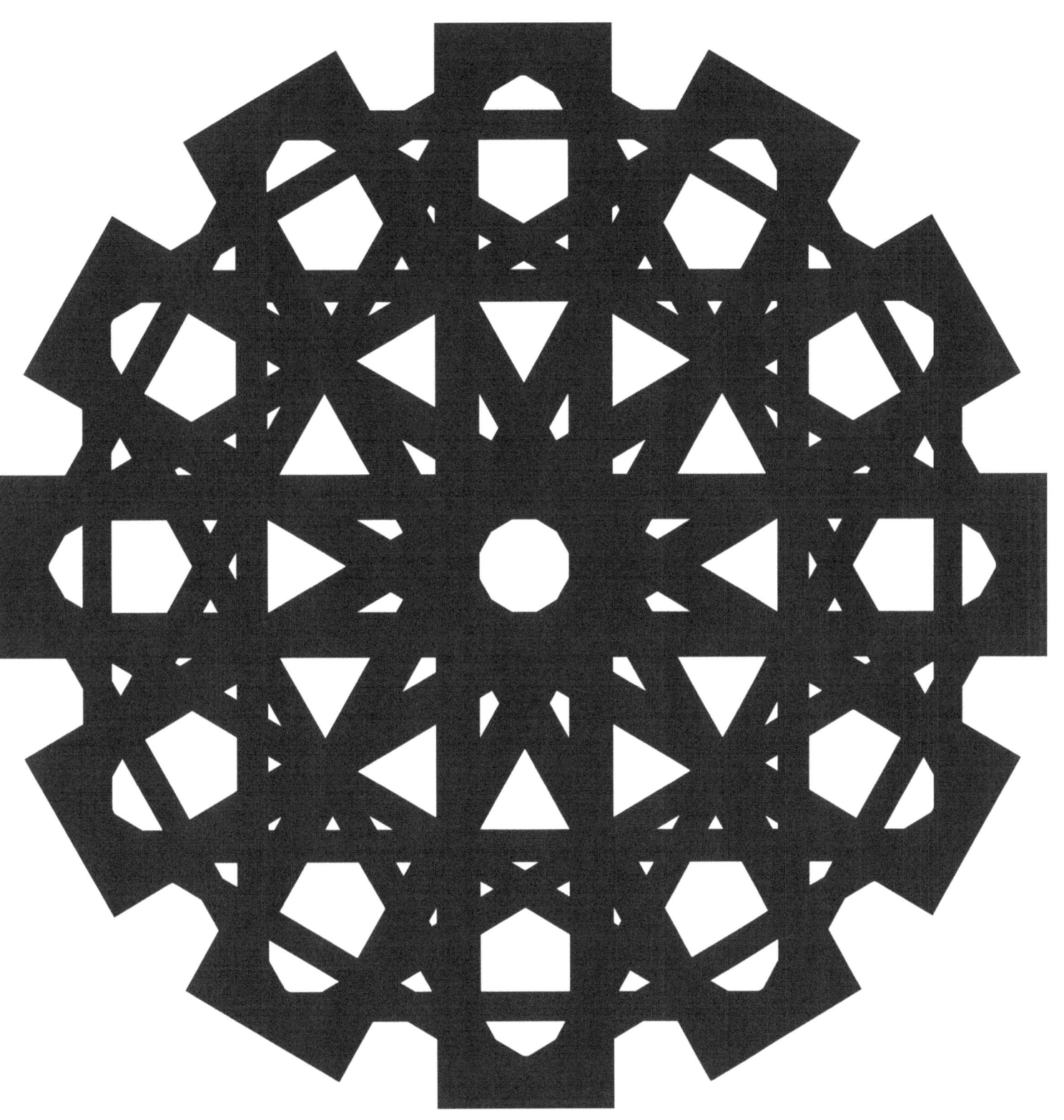

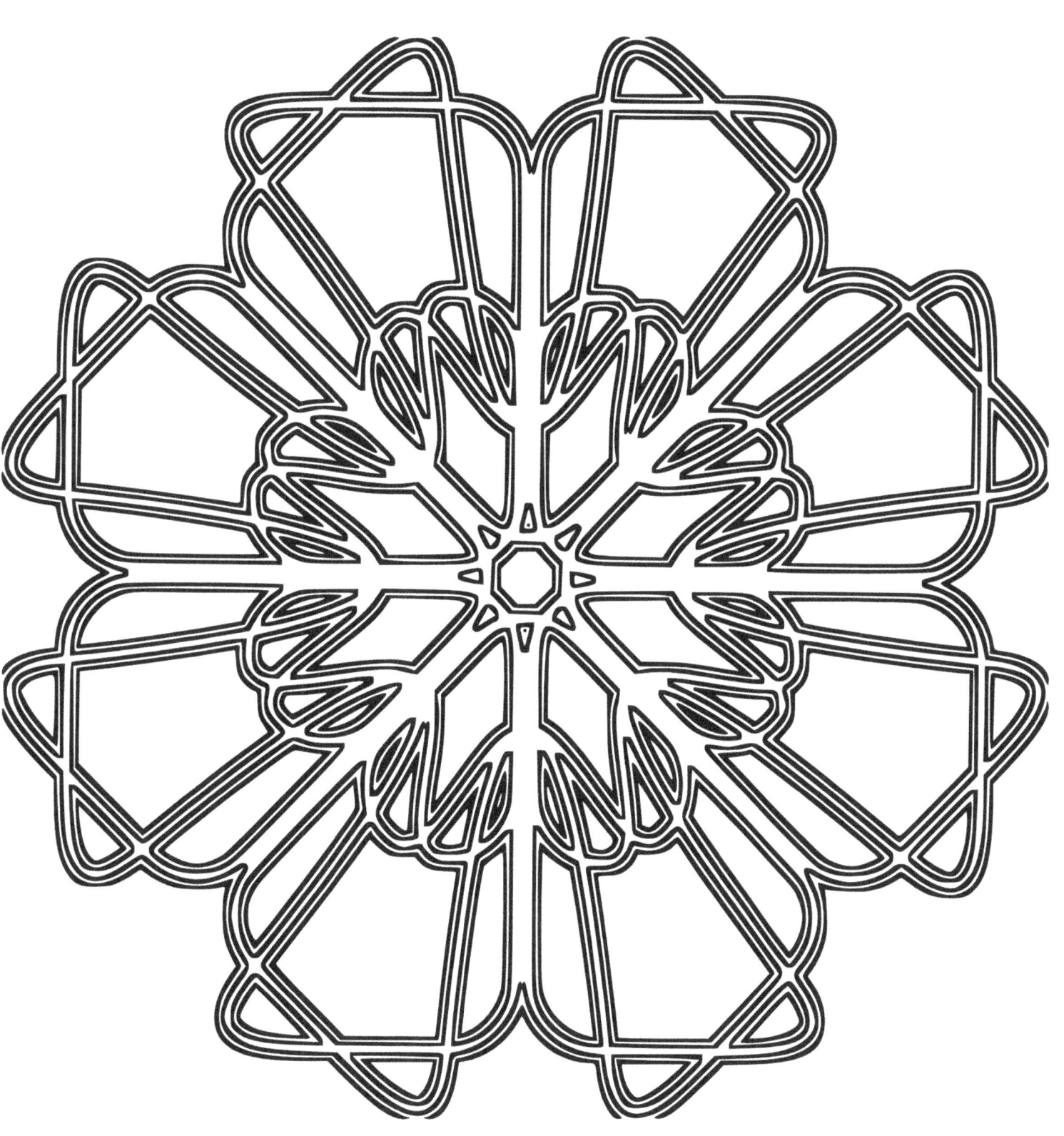

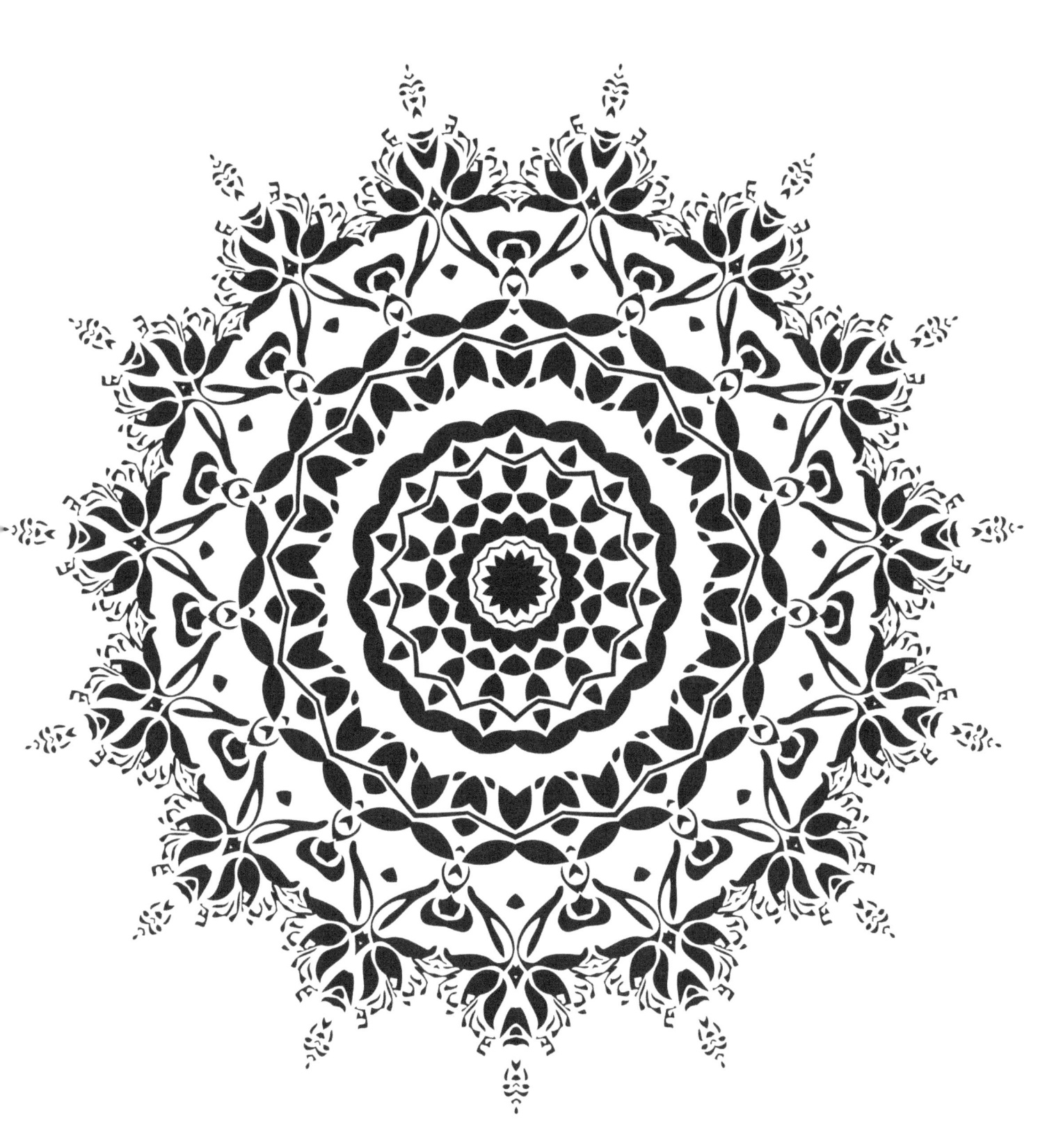

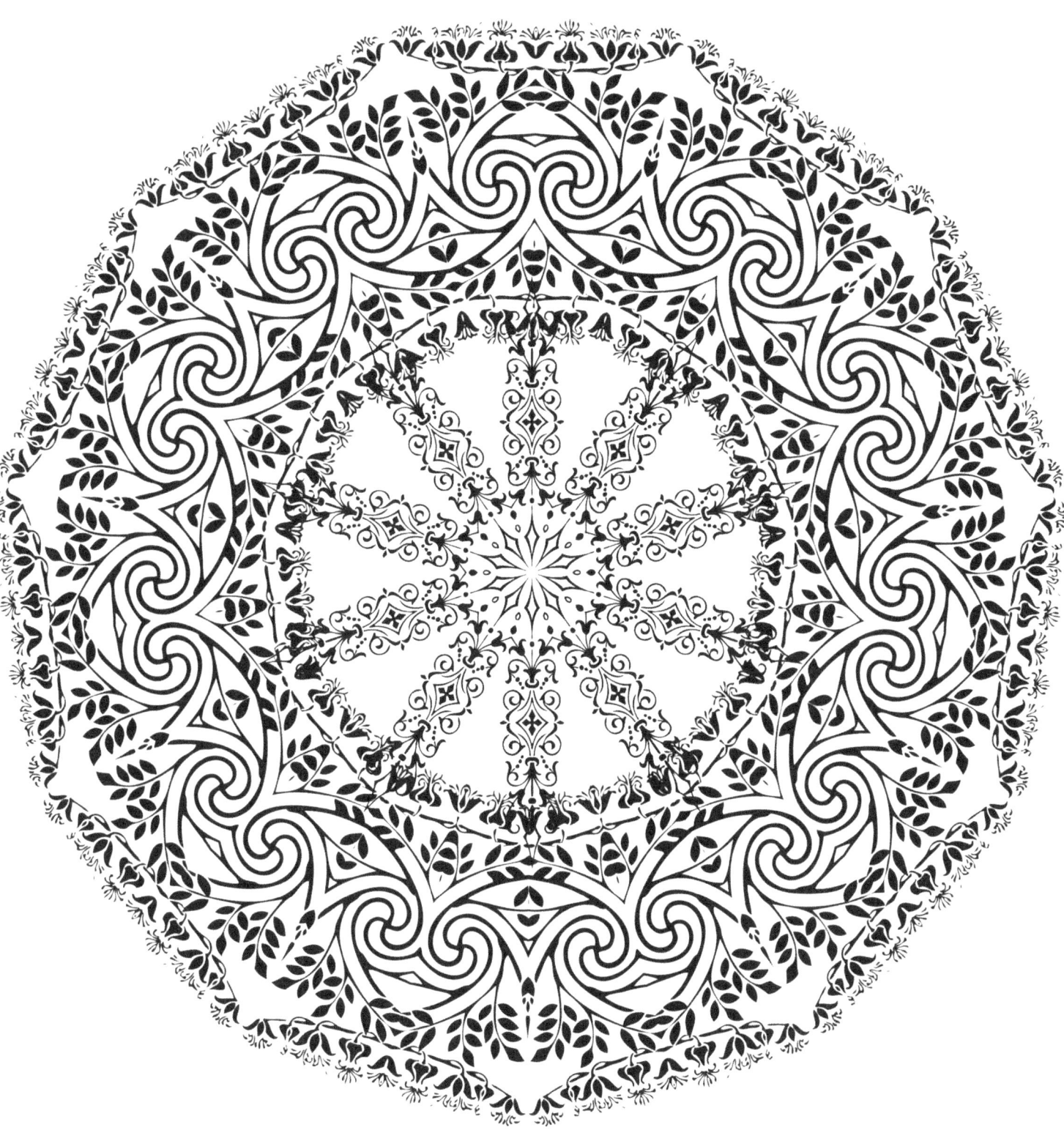

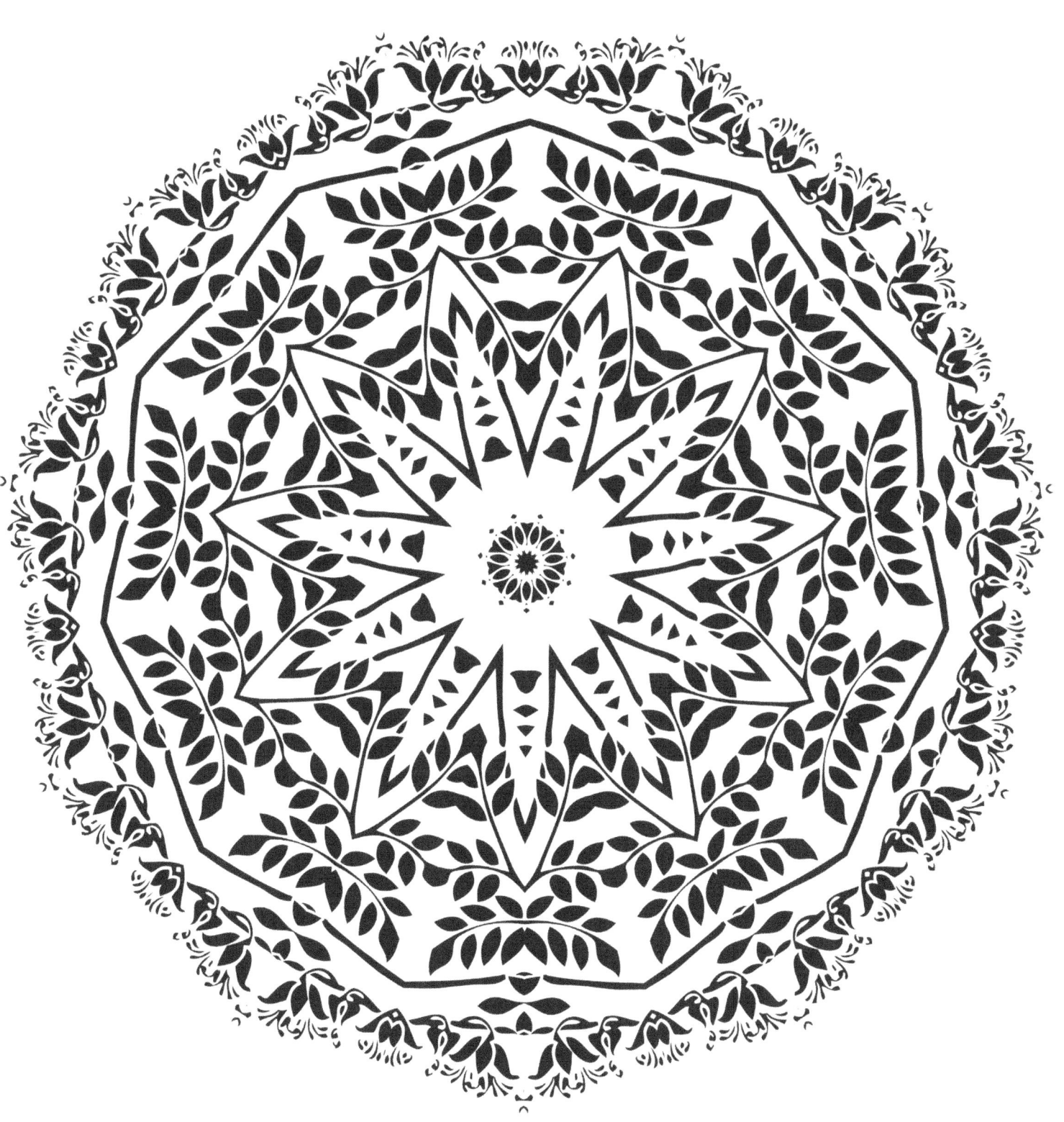

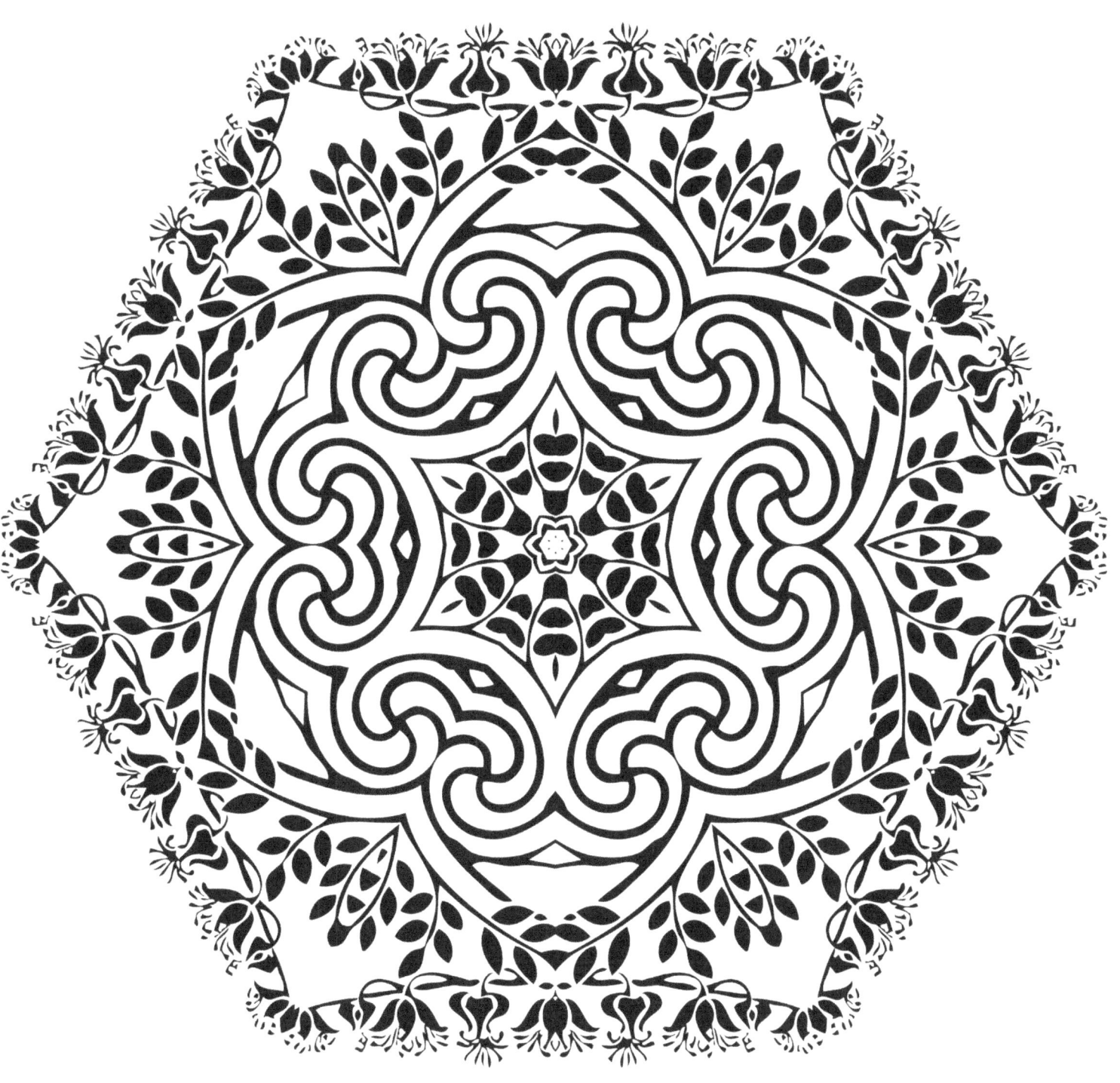

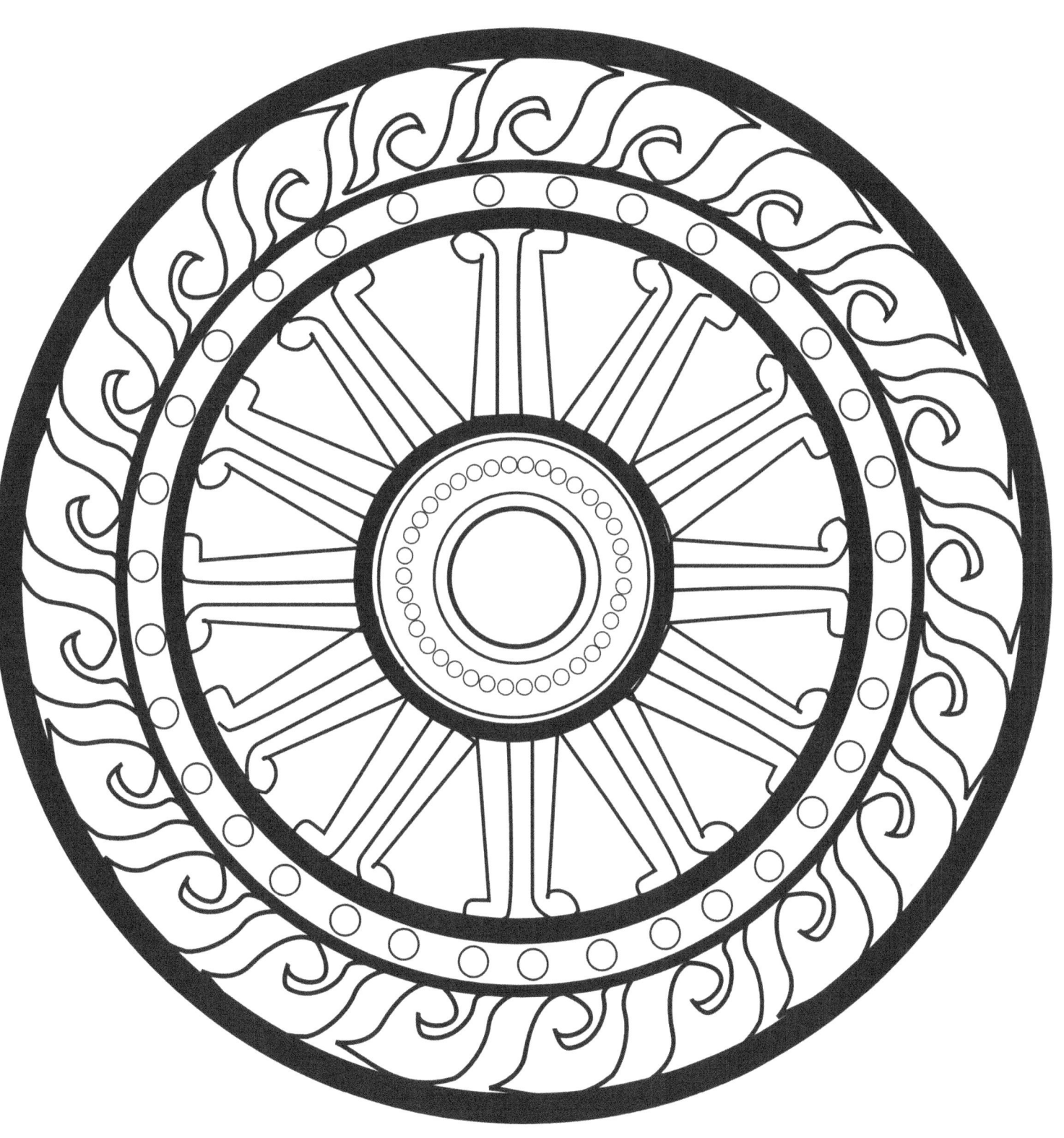

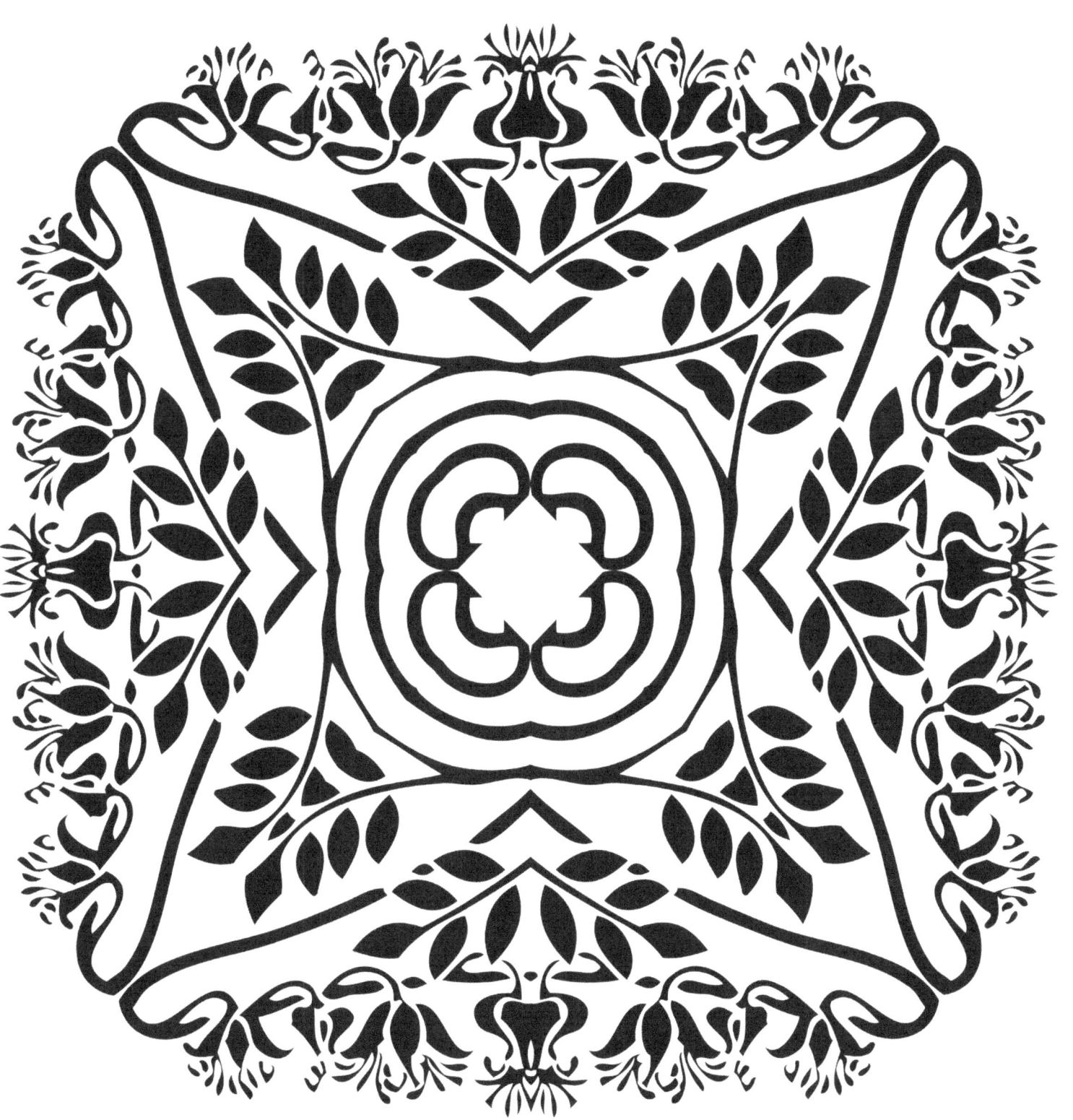

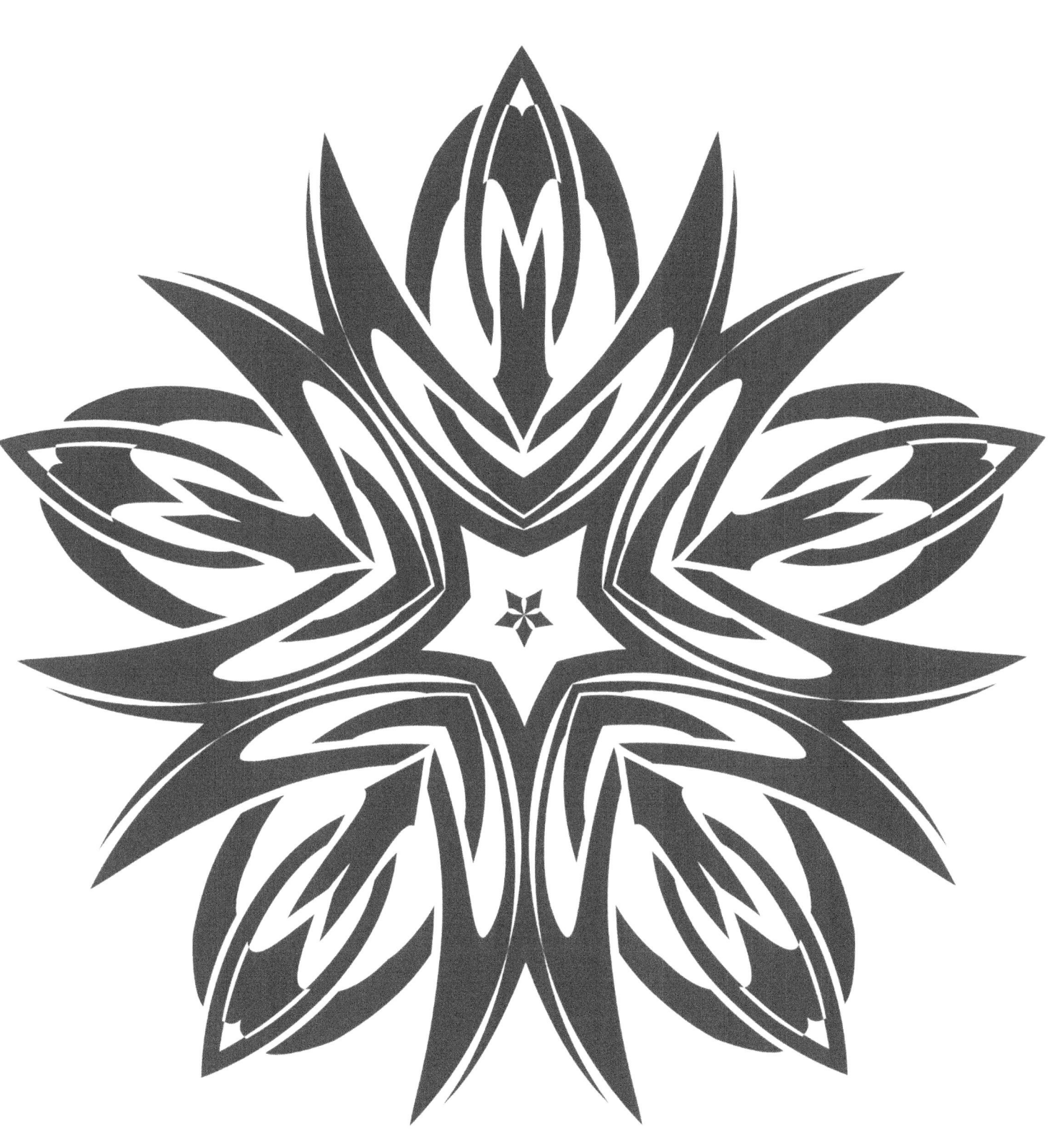

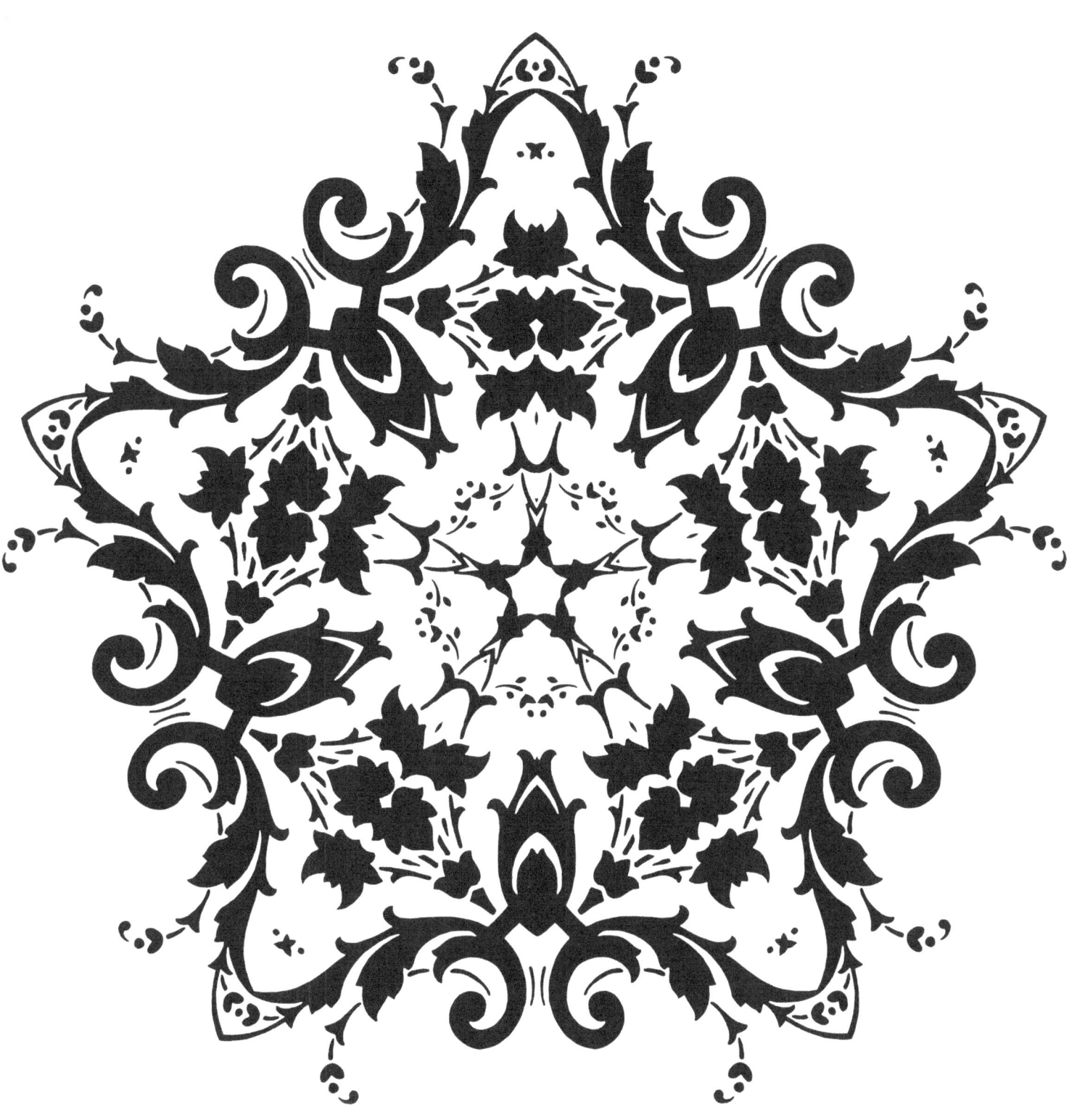

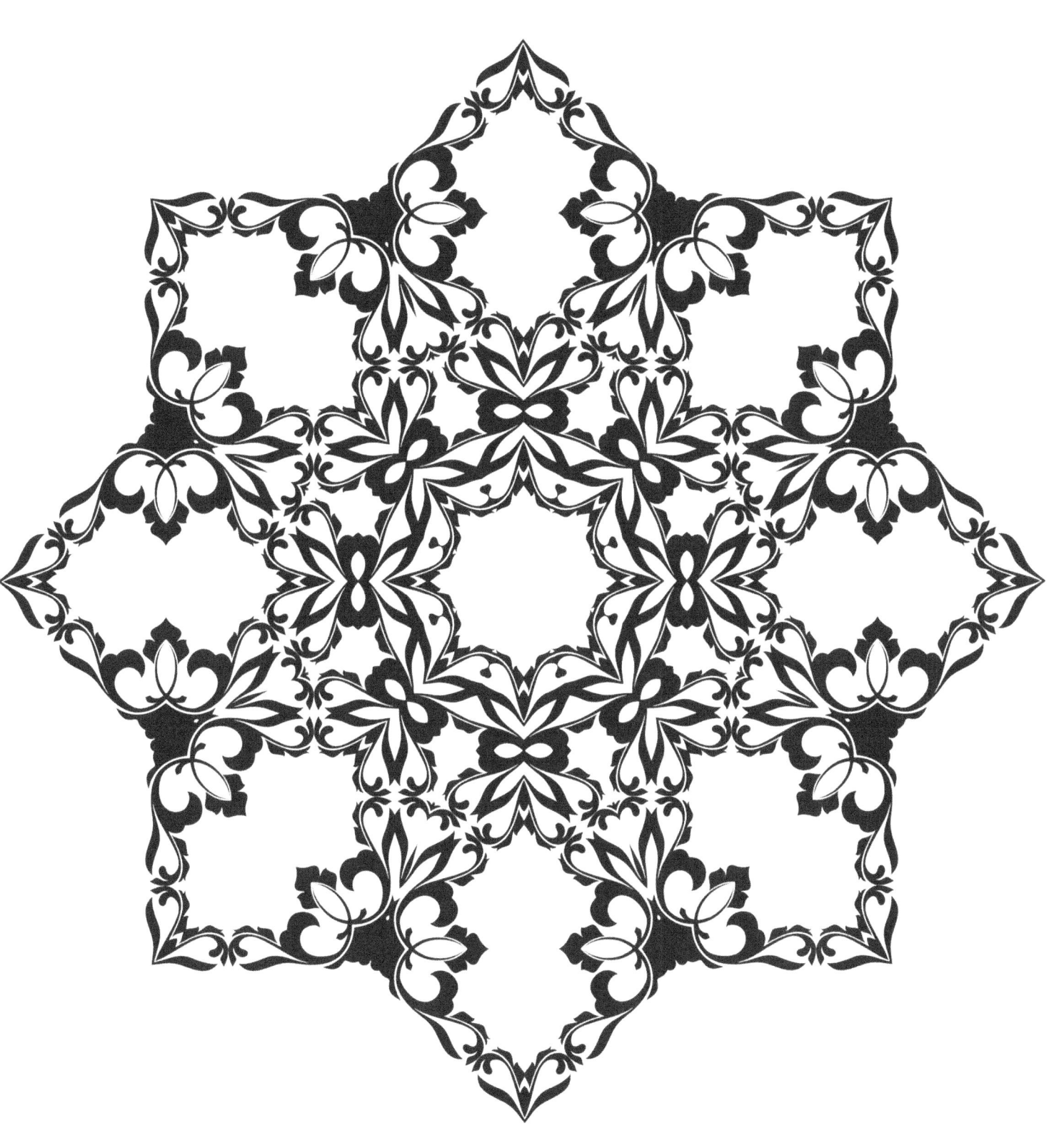

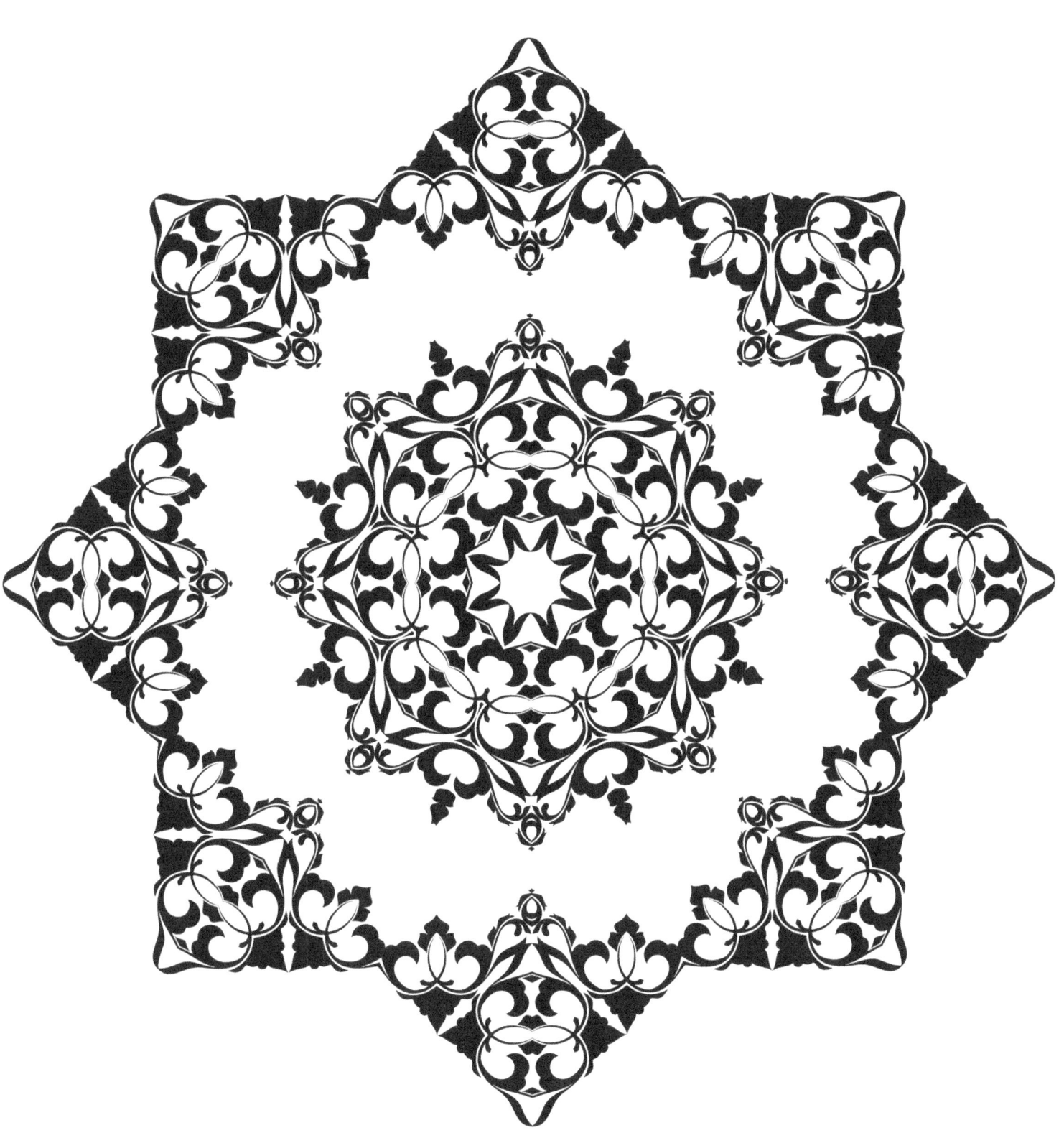

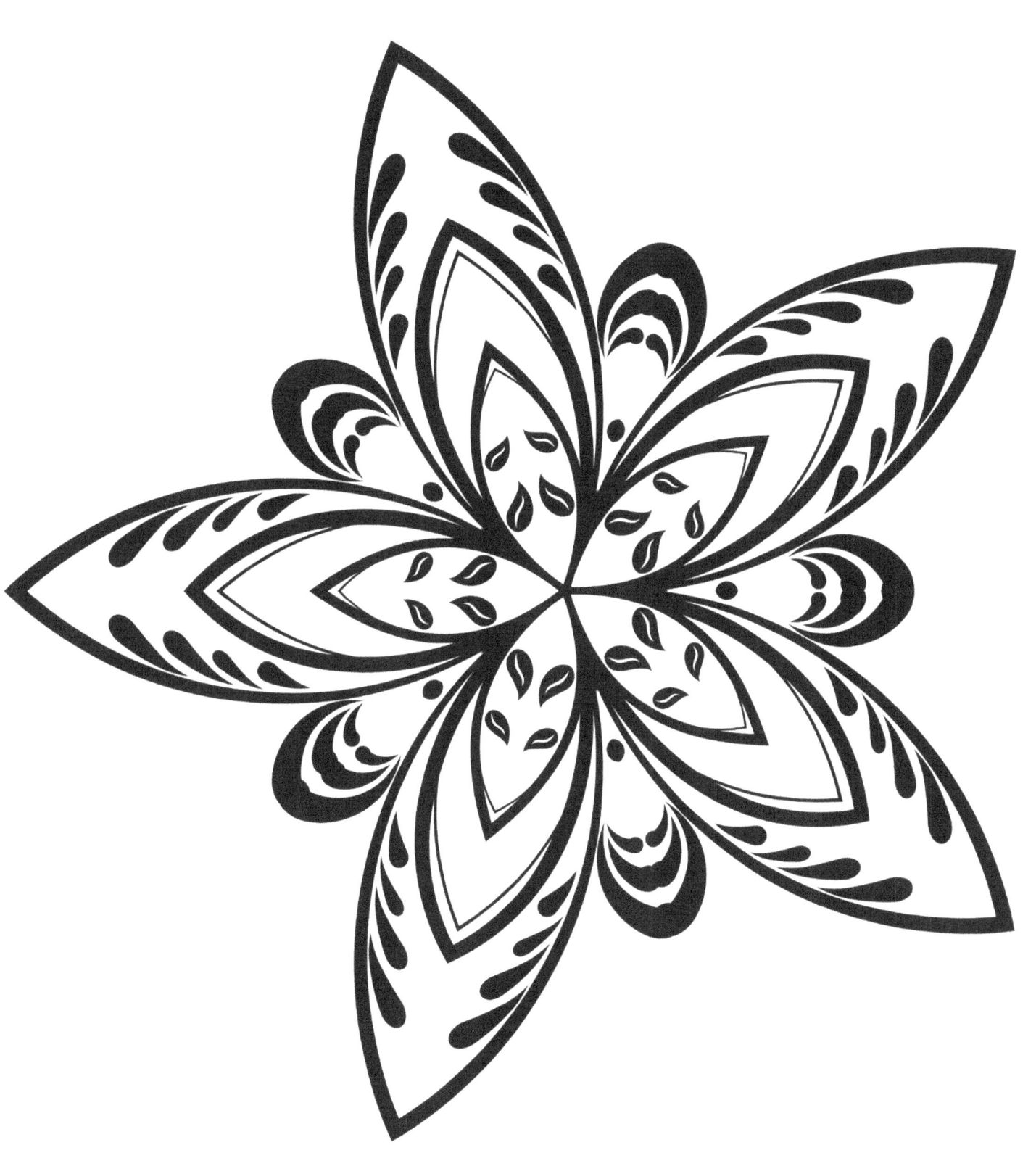

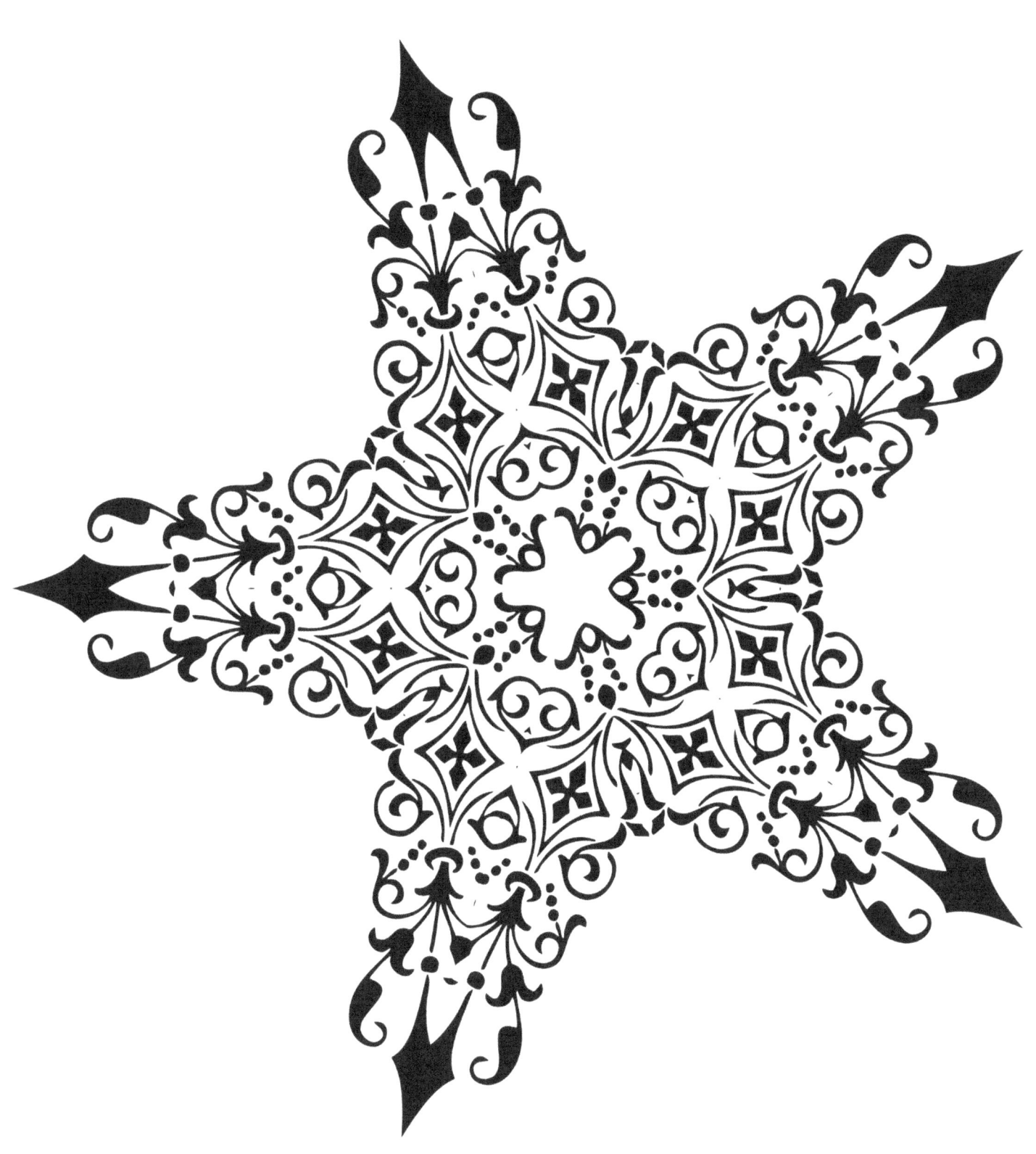

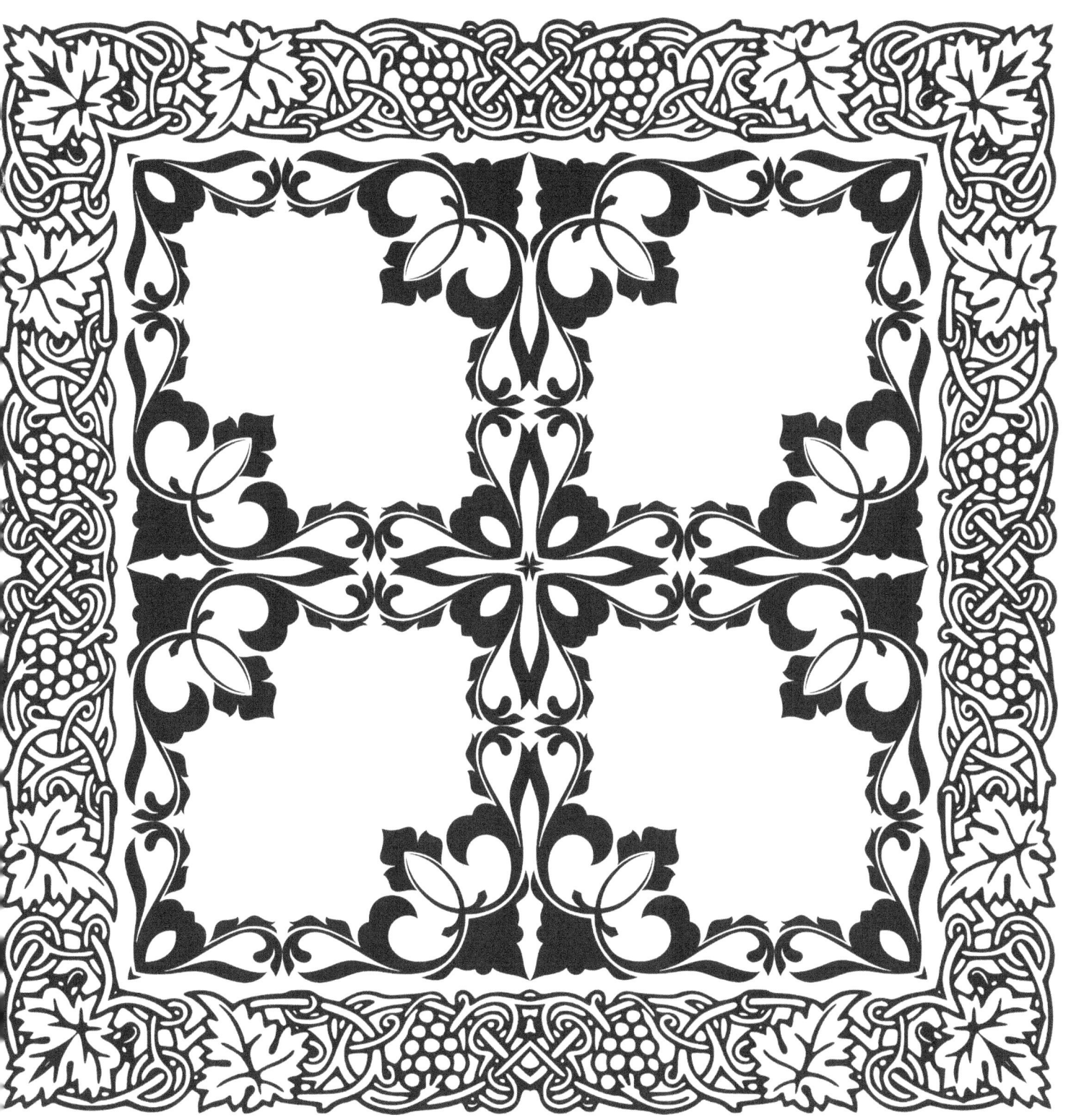

Here're Your Special BONUSES

Adult Coloring Book

PDF Download

www.acb.fihow.com

Download PDF Files for 51 Delectable Coloring Pages of This Book in One Zip File.

Conclusion

Thank you again for downloading this book!

I hope you enjoyed reading about my book on Adult Coloring Book : Coloring has been very inspirational for me. It's helped me a great deal as I am going through tough times. I really feel that it can help people out there that are grieving, anxious, depressed or just lonely. Coloring in the pages of an uplifting coloring book for an adult is very healing.

Adult coloring it is probably the best tool in my toolbox of things that can make my life, mood, stress, and overall health better. The popularity of coloring books for adults doesn't seem to be going away. In the beginning I thought it would be a passing fad but it looks like I was very wrong. There are a number and variety of people out there who have taken up this enjoyable hobby and there is no sign of slacking. Coloring is extremely reassuring and simple and has beautiful results. In this day in age, there aren't many things you can say that about.

Finally, if you enjoyed this book, please take the time to share your thoughts and post a review on Amazon. It'd be greatly appreciated!

Thank you!

Next Steps

Write me an honest review about the book – I truly value your opinion and thoughts and I will incorporate them into my next book, which is already underway.

Kindly Leave your review of my book…

Thank you!

www.ingramcontent.com/pod-product-compliance
Lightning Source LLC
Chambersburg PA
CBHW080620190526
45169CB00009B/3245